DRAWING
LANDSCAPES
FOR THE BEGINNING ARTIST

Contents

Landscape
& Drawing

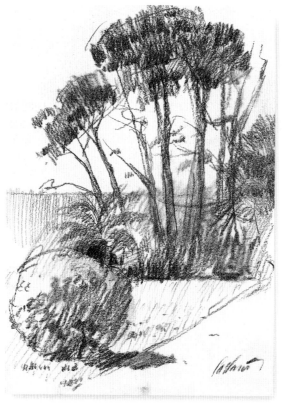

Techniques

The drawing techniques available to an artist are always the same: the use of lines, spots, shadings, tracings, and so on. The differences in the style, finish, and quality of the final drawing stem from how these techniques are organized, with methods and combinations selected from an endless variety of configurations. To exercise that richness in variety, the artist must have a full command of basic drawing techniques. This book introduces and illustrates those techniques so that the artist may approach the landscape for the first time confidently and effectively.

Basic Considerations in Landscape Drawing

The drawing of an object—any object—requires precise lines and a compact arrangement of light and shadow; it matters little whether the object is a container, a face, or a figure. Landscape drawing, however, is neither a purely imaginative task nor a fixed, stable reproduction of a solid object. It is something else altogether.

THE FORMS IN A LANDSCAPE

A landscape is an assemblage of forms: solid or airy, very broad or extremely fine, elemental or complex, distant or near. These forms appear before us without any overriding organization. It is impossible to make a complete rendering that includes every single element. So a drawing should suggest what it cannot represent, allude to the invisible by means of the visible.

A sensitively rendered sketch or doodle may contain unexpected suggestions within seemingly random lines.

Quickness in drawing is a sign of the artist's mastery of his means of expression—in this case, a concise and agile line.

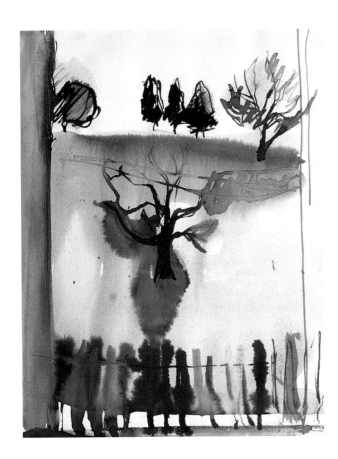

The development on the previous sketch uncovers many possibilities. Everything here was already implicit in the basic, almost childlike lines of the initial sketch.

Start simple. The most basic techniques are also the ones that most clearly express the artist's intentions, as well as the emotions experienced while observing the subject in nature.

THE ARTIST'S RESOURCES

If the key to success in landscapes lies in alluding to the whole by drawing only some of its parts, then the more suggestive the drawing is, the more effective it will be. The effectiveness of the drawing depends on the graphic techniques that the artist uses. Learning to draw landscapes is inseparable from learning the techniques of drawing.

Economy is the distinctive feature of sketches: A few lines suffice to define the space that each element occupies.

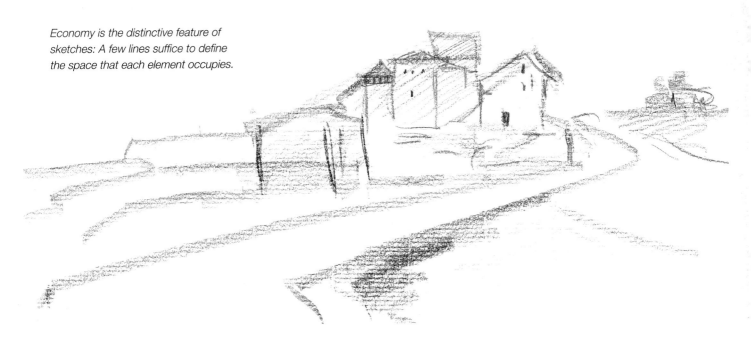

Graphic Media & Essential Drawing Techniques

The most basic graphic techniques are those that can be achieved by applying common drawing instruments in different ways. These instruments include graphite or colored pencils, charcoal, red ochre pastel, and India ink. The results vary a great deal depending on the precision with which an instrument is used and the motion used to apply it. The same instrument can produce lines, traces, hatching, spots, or tonal gradations. A logical place to start is by making a line drawing, and applying one of these techniques in order to take note of its results.

GRADATIONS

A gradation is a tone of decreasing intensity. The tone can be made with charcoal or red ochre pastel; it can also be a block of tracings in pen or pencil. With charcoal or pastel, the gradation is made by rubbing and extending the mark with your fingertips to reduce its intensity. If you are using a pencil, the block of strokes can be "graded" by reducing the pressure placed on the tip. Blocks of pen strokes are graded by decreasing the density of the strokes.

CROSSHATCHING

Crosshatching consists of lighter and darker webs of crisscrossing strokes. They are usually made by layering series of parallel lines in opposite directions (vertical and horizontal, or diagonal). Working in pencil or pen, crosshatching is the most common way to make some parts of the drawing darker.

Rubbing charcoal with your fingertip extends the mark and also reduces its intensity.

In red ochre pastel, curved lines and layers of spirals can be used to produce shading by varying the pressure.

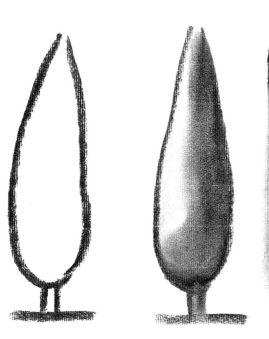

Adding gradations creates depth within a very simple line drawing in graphite.

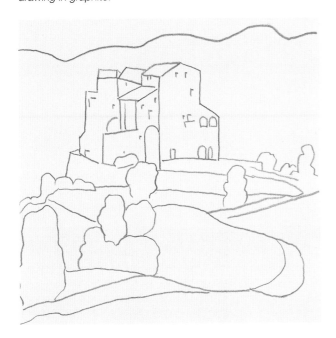

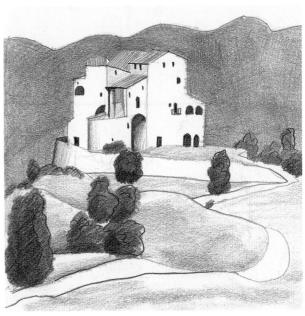

Working in pen makes it possible to create gradations by reducing the density of cross-hatched lines. These shadings are made up of layers of lines going in different directions.

To make gradations in graphite or colored pencils, vary the pressure applied to zigzagging lines.

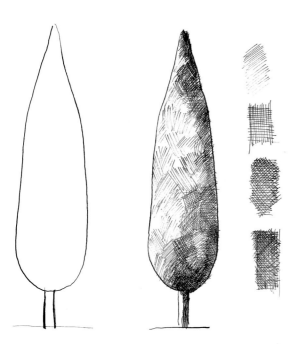

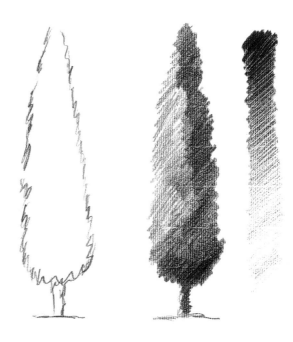

Using Lines to Describe & Strokes to Accentuate

In spite of their apparent similarities, the use of lines and strokes are different techniques. Line defines closed, precise contours, while strokes suggest open forms. A stroke is an accent that shows the essential characteristics of a form. Strokes come in a variety of forms: angular, comma-shaped, curved. Usually, these forms are repeated with a steady frequency throughout the drawing.

From top to bottom, the above marks were made with graphite pencil, red ochre pastel, pen, brush, and charcoal. The intensity of the stroke depends on the pressure you apply to the instrument.

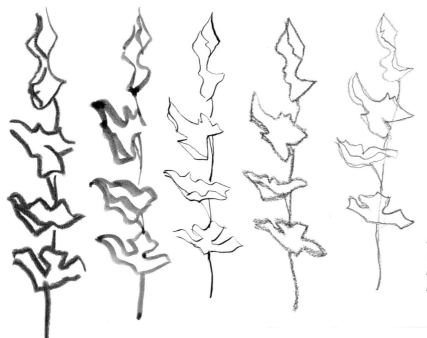

From left to right, these line drawings were made with charcoal, brush, pen, red ochre pastel, and graphite. These lines define closed forms.

WIDTH & INTENSITY OF STROKE

The drawing tool that you use can produce many different results in a drawing based on strokes. While charcoal provides a thick, warm, not very precise stroke, pen work is characterized by a cold, sharp, very precise stroke. Normally, the beginner starts out using pencil, preferably with a soft lead, which produces a thick, dark stroke. The pencil stroke will vary depending on how the point is applied to the paper: holding the pencil the way that you write, the stroke is narrow and even delicate; holding the pencil like a wand, the lead rests on the paper almost flat and the stroke is much wider, which is ideal for accentuating and reinforcing the drawing.

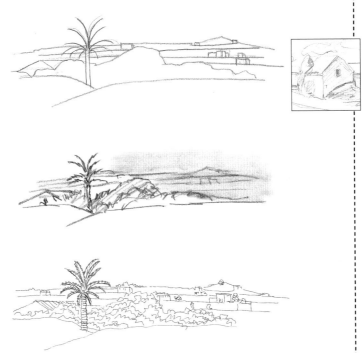

To take notes or let your imagination roam, use strokes to adjust, combine, and suggest the representation of the landscape. Strokes are more useful than lines when making tentative studies.

Working from the same view of a landscape, drawings made with strokes or with lines will be very different. The stroke merely suggests shapes, while the line defines them.

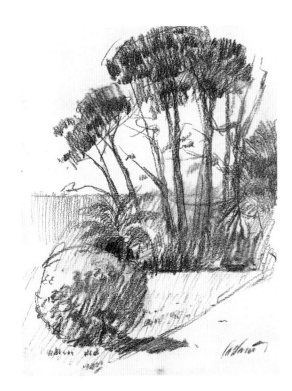

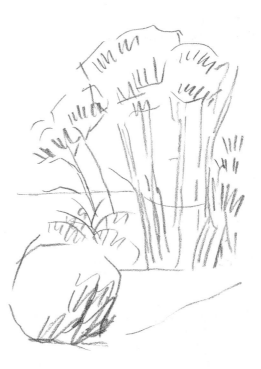

Strokes suggest the space between the shapes and the light surrounding them without enclosing any of them within strict boundaries.

In addition to allowing you to define contours, the lines of a drawing organize it within the boundaries of the page. The longer strokes mark the fundamental trajectories in the drawing and guide the rest of the shapes included in the work. The distribution of master lines in the drawing must establish different, well-defined directions. Avoid repeating the same orientation over and over again.

Using Lines to Organize a Drawing

Some landscapes offer excellent opportunities to make the line hold up the scene. In this snowscape, the fences create a charming, linear framing.

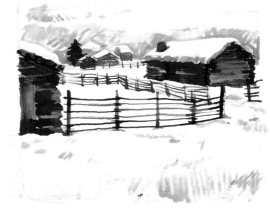

To create an effective drawing based on lines and strokes, the artist must achieve harmony between different line directions. These sketches show the rhythm and direction of the basic lines.

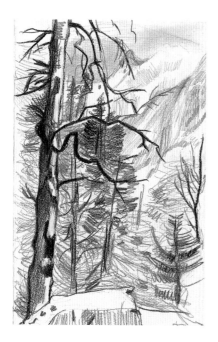

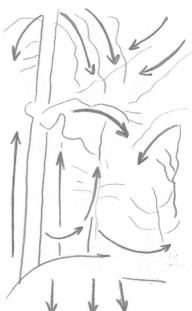

In this simple drawing, the organization of the landscape is based on linear trajectories laid out diagonally in relation to the line of the horizon.

The ornamental value of line is a product of the artist's imagination as well as his or her observational skills. Even a landscape—often the product of a great deal of reduction and simplification—can be ornamented with filigrees of line.

OPEN LINES

When you use line in landscape drawing, aim for an open composition. The line should not fully enclose the shape it describes; the contours of the objects must remain incomplete so that each shape interacts with the others.

THE AESTHETIC VALUE OF LINES

Line can acquire a special importance by relying on its grace or unusualness. In a line-based drawing with no accompanying strokes, the entire weight of the work rests on the evolution and trajectory of the lines, so they must be interesting on their own beyond their representational importance. Great landscape drawings often include some areas in which the lines have an additional, ornamental value that enriches the literal representation of the scene.

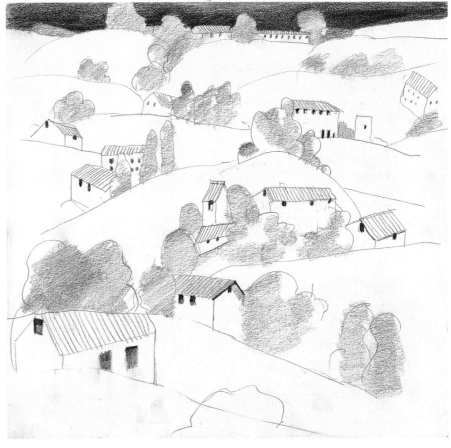

Representing Volume in the Landscape

Group strokes together to create "spots." Spots can add volume and mass or serve functions other than simply representing the details of the landscape. These extra functions are molding and expressing light, and they can be independent of the shape of the basic elements. You can even distort the characteristic contours of the drawing by creating masses of varying intensity.

SHADING & DRAWING MEDIA

Some drawing media are more effective than others in creating spots. Brushes, charcoal, red ochre pastel, chalk, or pastels allow you to cover the page quickly by creating lighter and darker blocks of tone. It is also possible to create spots by working with pencil or pen. To do this, build up dense hatching with crisscrossing lines. No matter what method is used, the use of spots as a basic medium means rendering the landscape in large blocks with very few additional details.

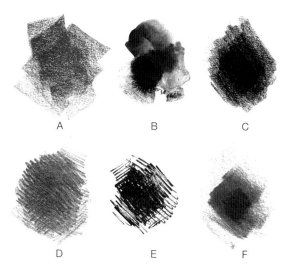

Spots created with red ochre pastel (A), paintbrush (B), pressed charcoal (C), graphite pencil (D), pen (E), and charcoal (F). Spots made with pencil or pen are always the most labor-intensive.

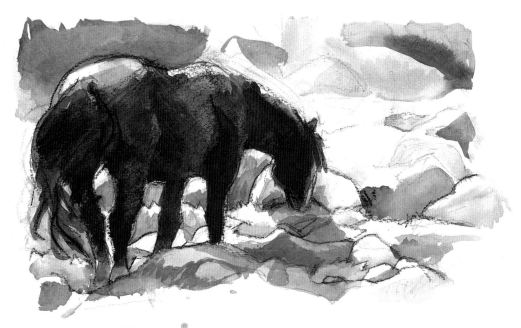

Ink, applied with a brush, is the easiest medium with which to create spots. Here, masses of varying tones leave little room for molding through light and shadow. The success of this piece hinges upon sensitive manipulation of the different intensities of ink.

In a landscape sketched in pen or pencil, the spots or masses will never be as compact as those made with charcoal or red ochre pastel, but the energy and vitality of the strokes will make up for this lack of solidity.

Landscape drawings based on blocks of shade require advance planning of the distribution of tones. Once the plan is clear, creating the final drawing will generally be quick.

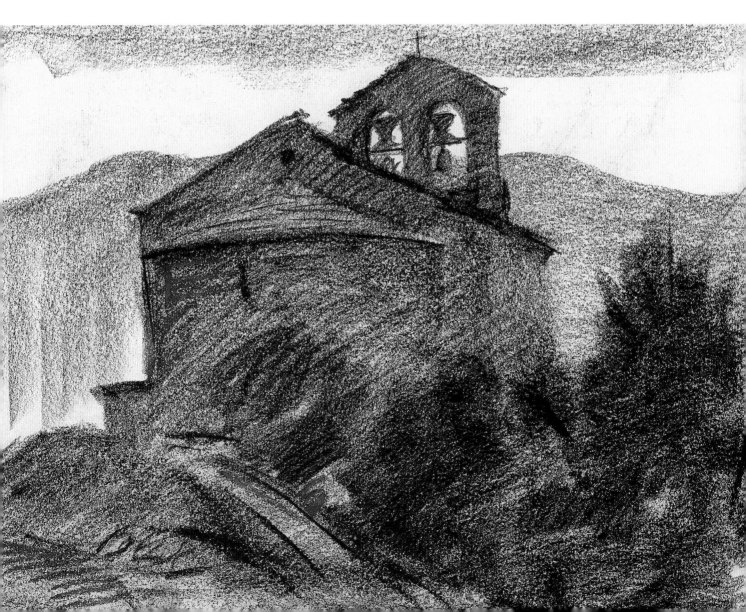

Partial
the

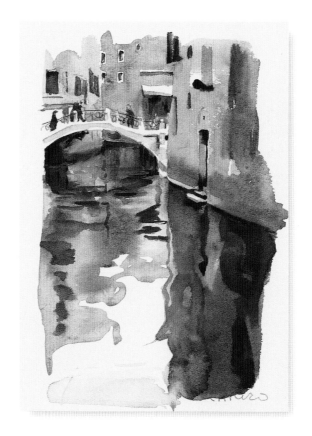

Studies of Landscape

From the point of view of the artist, the clearest characteristic of a landscape is its variety. The elements move through an endless series of combinations in which extraordinarily diverse forms interact. Any attempt to capture each one of them will be in vain. But you can establish large groups of shapes that are united by their similar configurations. This chapter shows you how to see the shapes in a landscape in large groups: vegetation shapes, mineral shapes, sky, and water.

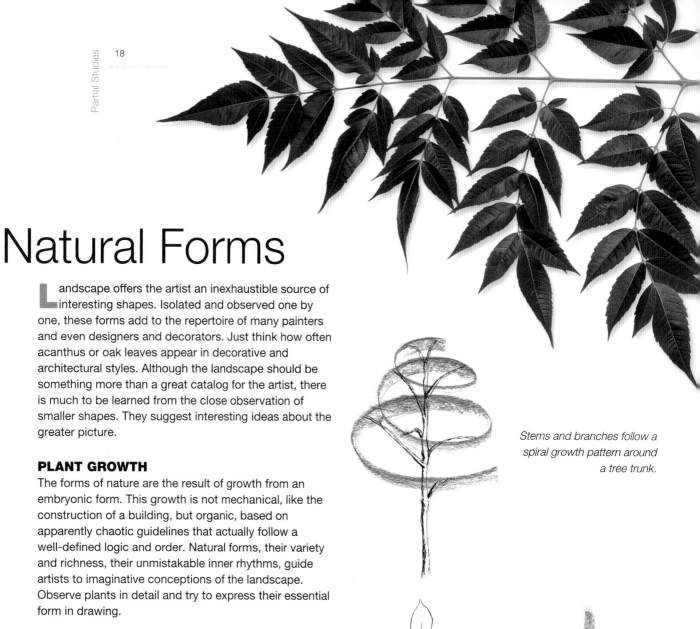

Natural Forms

Landscape offers the artist an inexhaustible source of interesting shapes. Isolated and observed one by one, these forms add to the repertoire of many painters and even designers and decorators. Just think how often acanthus or oak leaves appear in decorative and architectural styles. Although the landscape should be something more than a great catalog for the artist, there is much to be learned from the close observation of smaller shapes. They suggest interesting ideas about the greater picture.

PLANT GROWTH

The forms of nature are the result of growth from an embryonic form. This growth is not mechanical, like the construction of a building, but organic, based on apparently chaotic guidelines that actually follow a well-defined logic and order. Natural forms, their variety and richness, their unmistakable inner rhythms, guide artists to imaginative conceptions of the landscape. Observe plants in detail and try to express their essential form in drawing.

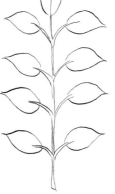

Stems and branches follow a spiral growth pattern around a tree trunk.

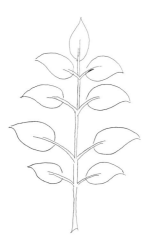

Plants do not grow neatly: groups of leaves are different distances from one another, and the youngest leaves are closest together. Likewise, the width of the plant is always smaller in the youngest part.

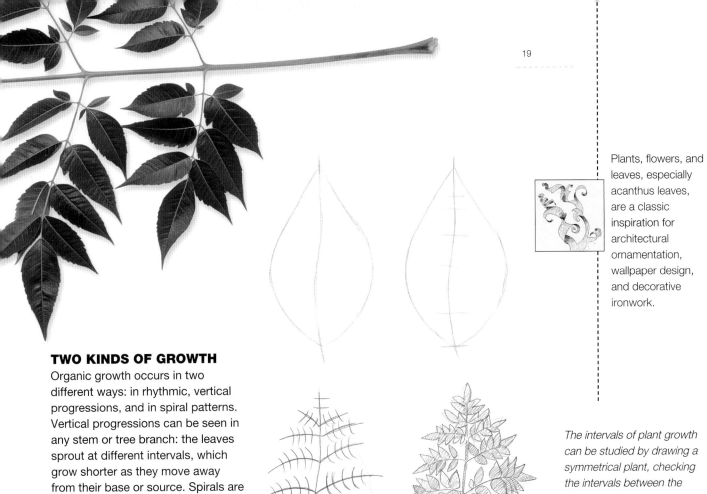

Plants, flowers, and leaves, especially acanthus leaves, are a classic inspiration for architectural ornamentation, wallpaper design, and decorative ironwork.

TWO KINDS OF GROWTH

Organic growth occurs in two different ways: in rhythmic, vertical progressions, and in spiral patterns. Vertical progressions can be seen in any stem or tree branch: the leaves sprout at different intervals, which grow shorter as they move away from their base or source. Spirals are visible in many flowers—sunflowers, for instance—but the arrangement of leaves around a branch also follows a spiral pattern in order to make best use of the sunlight.

The intervals of plant growth can be studied by drawing a symmetrical plant, checking the intervals between the branches, and the full form of the plant, which tends to echo the pattern of each of its leaves.

Always keep in mind the harmonic distribution of spaces in between branches.

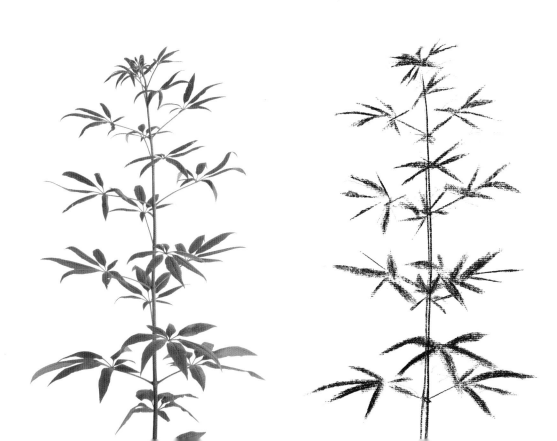

Tree leaves lend themselves to two different kinds of drawings: representations of single leaves and representations of groups of leaves, which can lead to the representation of trees. The former involves fairly literal line work, perhaps accompanied by some strokes or shadings; these drawings are relatively easy, especially if the artist uses simple geometric outlines. In the latter case, it is necessary to reduce some of the details of each leaf in order to create the whole; a nearly complete leaf may stand out here and there, while the rest should only be implied.

Studying & Drawing Plants & Leaves

OUTLINES & OTHER DRAWING AIDS

Exercises in drawing leaves and other plant details demand quick, intuitive work on the part of the artist, with few details and no lingering. The strokes should be simple and decisive, and the resulting form should be clear and instantly recognizable. Starting out with simple geometric shapes is very useful for beginners looking to reach this degree of confidence. These very simple geometric outlines will, when used as a preliminary step, allow you to orient the drawing in terms of general proportions as well as the specific profile of the plant.

Leaves and other plant forms can be outlined in a simple line sketch. Using this outline, it is much easier to draw each part of the plant in proportion and achieve a convincing representation.

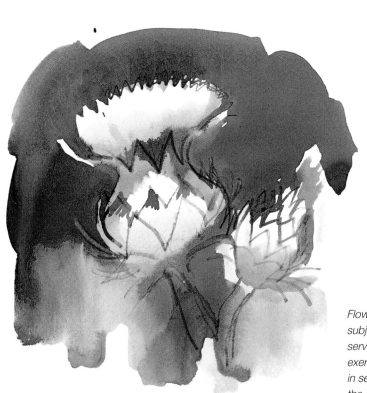

Drawing branches and clusters of leaves should go beyond a purely linear description—it should be a graphic summary of the contours and shadows surrounding the entire subject.

Flowers are always an attractive subject for the artist, and also serve as an excellent drawing exercise. This drawing, shaded in sepia-colored ink, expresses the essential form of the plant.

Gather leaves and branches in a park or in the country and draw them at home or in your studio. First, sketch the lines of the leaf's basic, geometric outline, then elaborate on that sketch as much as you wish.

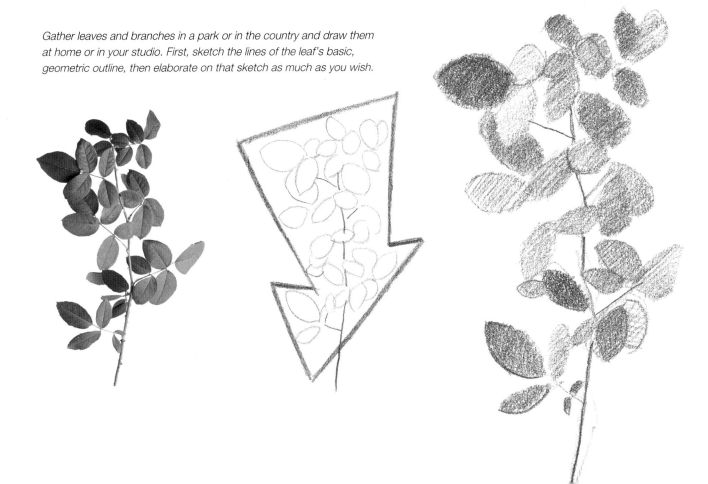

Studying & Drawing the Shapes of Trees

Trees are fundamental elements of almost any landscape. Most professionals have an ample repertoire of tree outlines that they can recall easily and use conveniently when sketching or working from memory. This repertoire is the product of careful studies made from nature. For the beginner, it is essential to pay close attention to the precise form of every tree in order to capture its characteristic silhouette, and to master the appropriate stroke for representing its leaves. As with leaves and plants, drawings of trees should also begin with the simplest outline possible.

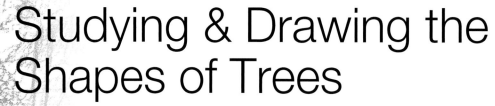

Like leaf drawings, drawings of trees can be summarized in just a few lines based on the shape of the treetop. Using this outline as a starting point makes it easier to find your way when drawing the branches and foliage.

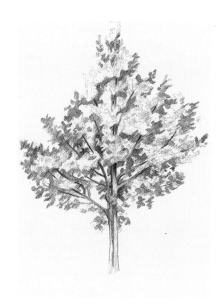

This delicate red ochre pastel sketch is the result of closely studying a group of trees. Studies such as these allow the artist to collect mental images of natural forms—very useful in later work.

FREEDOM & CONTROL OF THE STROKE

As an artist, your work should be confident and free, but this is only attainable when you possess a clear mastery of the stroke. To get this mastery, start out sketching the outline, then add the tree's shape quickly, in a single stroke. At first the results will not be very satisfying, but with practice you will be able to complete the contours and foliage of any tree in a convincing, evocative manner.

Sometimes, a tree is best characterized not by its foliage but by the trunk, or by the differences in tone between the trunk and the leaves. This is the case with these chestnut trees.

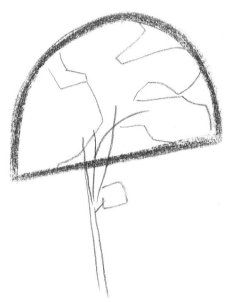

These images show the logical sequence of steps in the drawing of a tree's shape. Starting from a basic sketch of the trunk, crown, and leaves, define the basic profiles and the basic shadows that give the foliage its distinctive appearance.

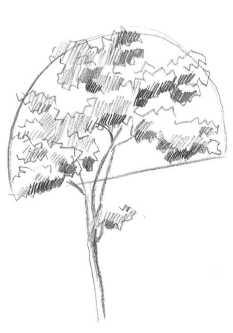

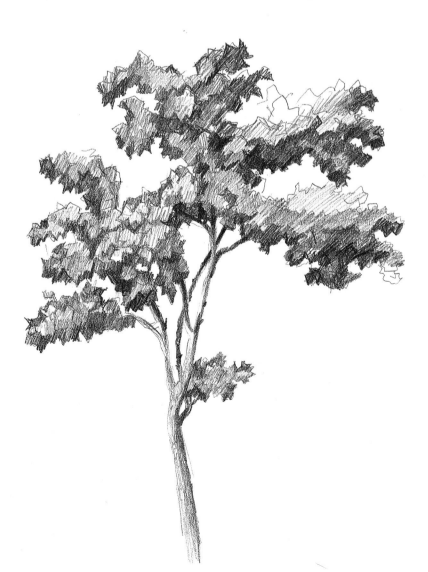

Drawing Rocks & Other Mineral Forms

Unlike plants and other organic forms, rocks are not a product of growth. Their shape is the product of mechanical forces that frequently result in seemingly random configurations, usually based on a geometric regularity. For this reason, rocks are generally easier to draw than plants. The initial geometric sketch can be developed using just a few variations, such as outlining the edges and faces of each initial shape. Shading is always essential, because the characteristic shapes of rocks can rarely be expressed through line alone.

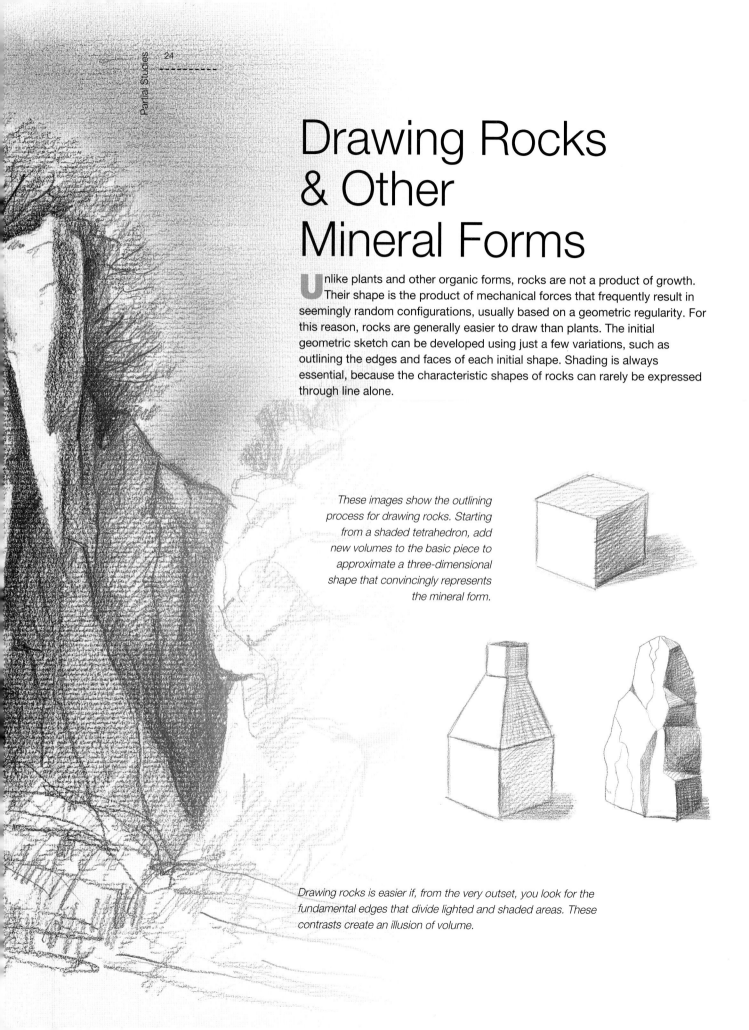

These images show the outlining process for drawing rocks. Starting from a shaded tetrahedron, add new volumes to the basic piece to approximate a three-dimensional shape that convincingly represents the mineral form.

Drawing rocks is easier if, from the very outset, you look for the fundamental edges that divide lighted and shaded areas. These contrasts create an illusion of volume.

CUBICAL SKETCHES

The most useful outlining technique for drawing rocks is the cubical sketch. This sketch takes the tetrahedron as its starting point, defining its faces and edges, and shading in a conventional manner. By adding new bodies and volumes to this tetrahedron, you can effectively complicate the basic sketch and approximate the shape of the real rock. Naturally, the shading of this complex form should be coherent with the light and shadow of the cube that served as its starting point. Once you understand the global structure of its form, it is easier to soften the edges, add details, and generally give character to the particulars of the rocks represented.

This sequence shows the simplest approach to the representation of rocks. A line drawing is not enough—you must add simple shadings that reflect the rock's volumes. In the last step, the drawing is completed by adding detail to these shadings.

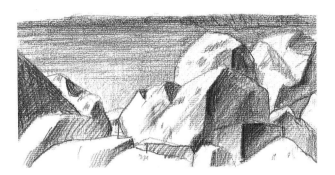

Once you understand the fundamentals of drawing rocks, you will be able to summarize rocky landscapes with a few lines and some well-placed shadows.

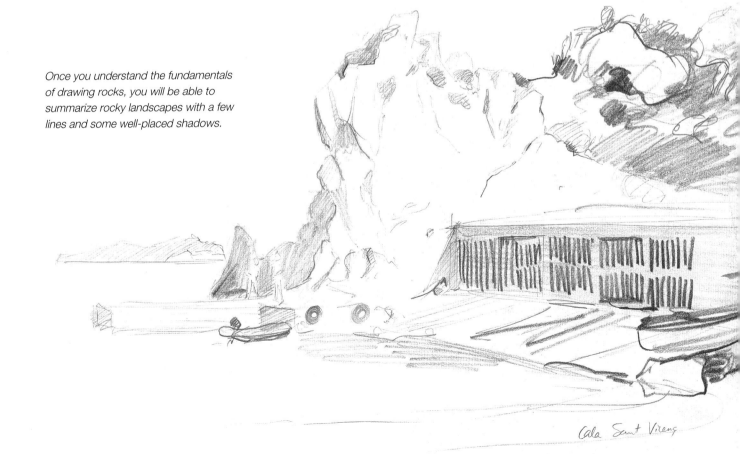

Cala Sant Vilens

The Problem of Drawing the Sky

The sky, if we put aside clouds for a moment, is nothing more than space—a void in which there is no room to represent anything else. But instead of making things easier for the landscape artist, this complicates matters because you cannot simply fill in the space at your convenience as you can with other parts of the landscape. Empty spaces in a drawing are the decision of the artist; the empty space of the sky, however, is not: It is imposed by the landscape. In light of these facts, the artist can choose from among several different options.

BALANCED TONES

The contrast between strokes and spots in the landscape against the space of the sky works if the artist is careful to also leave blank spaces on the ground, spaces that lighten the tones in the lower part of the drawing. If the ground is too dark, the artist is forced to darken the sky, if only slightly, in order to create a relationship between the tones and a general sense of harmony.

The total shading of a drawing must be balanced between the great empty space of the sky and the earth below it.

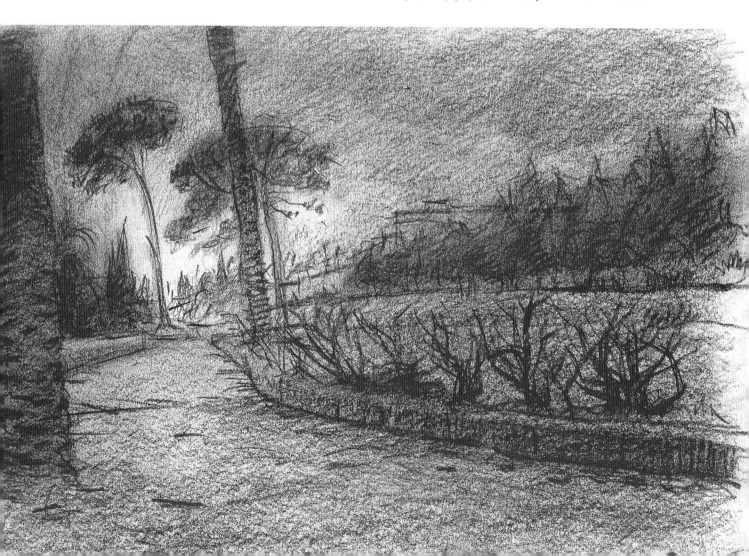

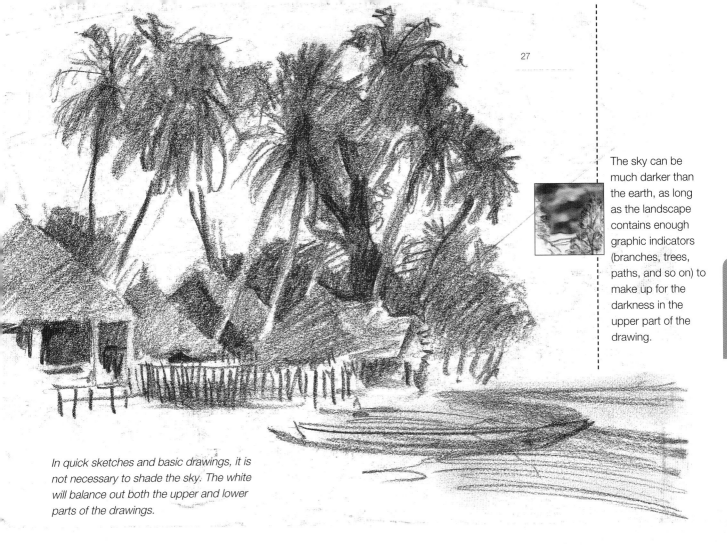

The sky can be much darker than the earth, as long as the landscape contains enough graphic indicators (branches, trees, paths, and so on) to make up for the darkness in the upper part of the drawing.

In quick sketches and basic drawings, it is not necessary to shade the sky. The white will balance out both the upper and lower parts of the drawings.

GRADATIONS

When you want your drawing to be tonally compact, the most logical thing to do is to make a light gradation in the sky. It is important for this gradation to be lighter in the lower regions, where the sky is closest to the horizon, than in the upper regions; this is how the sky tends to appear in reality. This method not only allows for a general harmonization of the drawing, it also creates a convincing lighting effect.

If a drawing is shaded all over, the tone of the sky (as long as it is cloudless) should be more or less equal to that of the earth. But it should be lighter in the area closest to the horizon.

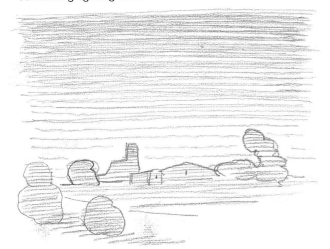

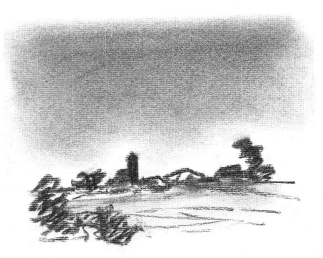

Clouds provide the landscape artist with a wonderful excuse to give free rein to his or her graphic imagination. These changing, vaporous shapes cannot be firmly enclosed in stable contours. Instead, they allow you to alternate different strokes, spots, and smudges with total freedom. Nevertheless, you must take some precautions to ensure that the clouds do not depend entirely on your imagination.

Graphic Techniques for Representing Clouds

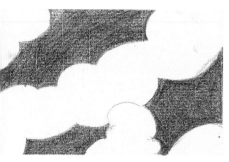 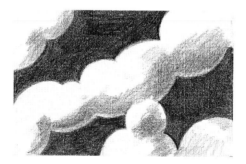 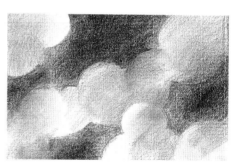

1. Drawing clouds can be as simple as drawing a few cottony shapes against a dark background.

2. This simple shading creates a somewhat artificial appearance of volume.

3. The shading should blend partially with the tone of the sky to create an atmospheric effect.

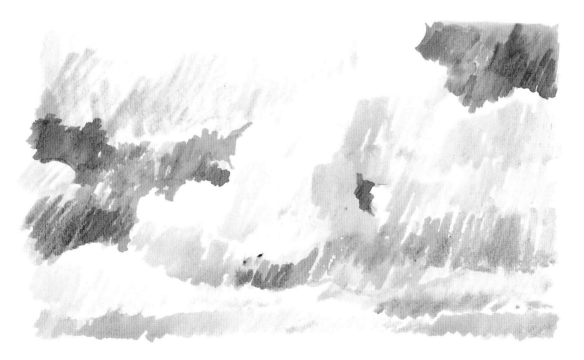

This drawing, based on strokes, shows an intelligent gradation of intensities. The shapes of the clouds are faded in some areas so that they appear to blend into the background.

ATMOSPHERIC SHAPES

The representation of clouds is intimately related to the representation of the atmosphere, which cannot be enclosed within precise limits. Therefore, drawings of clouds should not be too firm, and their shape should blend in here and there with the background. You can achieve this by using fading or stumping (blending or fading using a nub or stumping pencil) or strokes that alternate between white and hatched areas, going in and out of the border of the cloudy shape. Allow some edges to stand out against the background while others fade into it.

Drawing clouds is most effective when the shapes are suggested rather than clearly defined. Here, the contrast between the blue of the sky and the white of the clouds gets lost in many spots, yielding to intermediate tones.

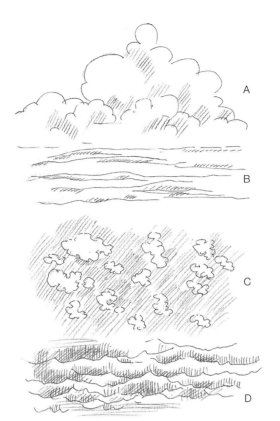

Clouds are always a luminous element in the representation of the landscape. They tend to be much lighter than the sky, so they open up white spaces in the drawing and add light and an atmospheric feel tto the work.

This is a simple visual guide to clouds in which you can see the contours of cumulus (A), cirrus (B), and nimbus (C) clouds, and the mass of stormy rainclouds (D).

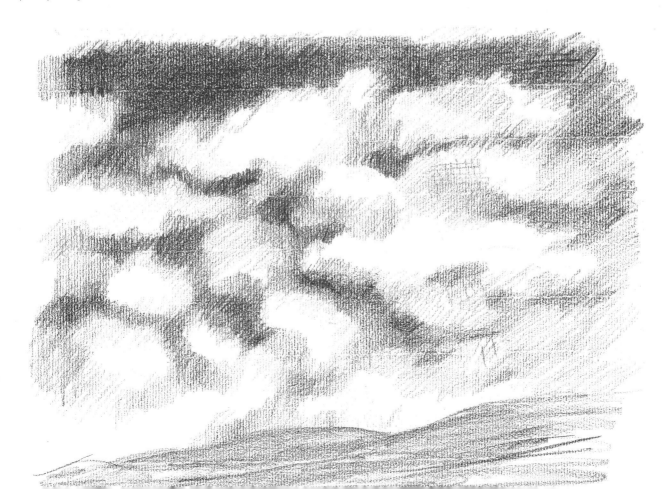

Drawing Water

The surface of water is manifested by its waves, which distort the images reflected on the surface and transform them into a mesh of light and shadow. This wave effect can be produced by using strokes or tiny spots that grow more dense as the reflection that they define becomes brighter, and that grow wider when they are closer to the foreground. Your strokes should be smaller the closer they are to the horizon, because they represent waves that are far removed from the viewer. Be flexible, and pay attention to the water's appearance in each case.

Avoid a systematic treatment of the strokes you use to represent the water. Instead, work toward achieving spontaneity and vigor in your lines so that the drawing shows the vibrations on the water's surface.

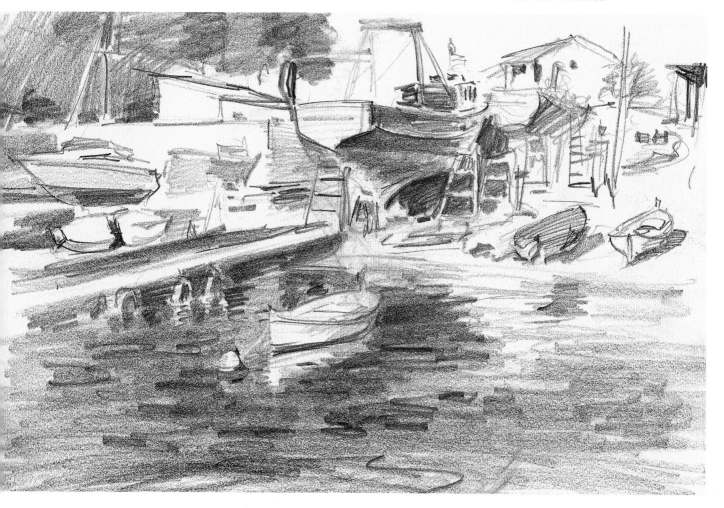

Thoughtful spreading of simple strokes is one of the best graphic techniques for representing water. Your strokes should be longer and more intense in the foreground, and their direction should suggest the way the waves collide with one another.

ARABESQUES

Arabesques are linear filigrees or, to put it simply, curved strokes that move rhythmically in different directions. The purpose of arabesques is to create a sensation of harmonized motion that serves as both representation and ornament. In a landscape, water can evoke the richest arabesques. Take advantage of this to let your imagination roam freely without forgetting your starting point. In general, arabesques should accompany other line techniques—whatever techniques are appropriate to drawing your solid objects—which lend firmness and solidity to the representation of the water.

Simple, clear lines are one of the best ways to represent water. The lines should be more intense and long in the foreground and should suggest the movement of the waves.

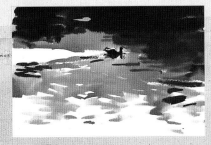

Whether you're using strokes or spots, the foreground of the water's surface should leave room for white spaces, and the darker tones of the waves should be larger than they are in the more distant parts of the landscape.

In very atmospheric landscapes, water can be represented by a simple plane with an almost uniform tone.

Reflections on the Surface of the Water

The principle that governs reflections on water is the same that explains the reflection of an object in a mirror. An object resting on a mirror in a horizontal position appears inverted on its own base; the reflection duplicates exactly the shape and size of the object. Something similar occurs with brightness.

THE TONE OF REFLECTIONS

Objects in a landscape are almost always lighted from above; their reflections show the lower part of the objects—the part that is least lighted—and inverts their images. It follows that reflected objects in the landscape are necessarily darker than the actual objects. They will be darker the higher your point of view is—in other words, the farther up you are from the surface of the water.

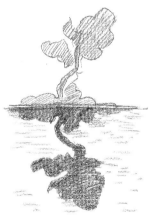

Calm water reflects the shape of the shore just as a mirror would, although the tone of the reflection is always darker in the water.

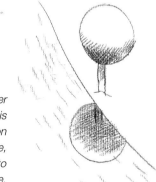

The reflection gets darker when the point of view is higher. We see the reflection of the lower part of the shape, which is the part that tends to lie most in the shade.

BRIGHTNESS

For the artist, brightness is represented by the blank spaces on the page. The white of the paper is the lightest value the artist can achieve. Distribute brightness according to the logic of the waves' motion. Thus, the bright areas should be much larger in the foreground than in the distance, because the waves offer a larger surface on which to reflect light. Graphically, the solution comparable to the technique used to represent waves in general.

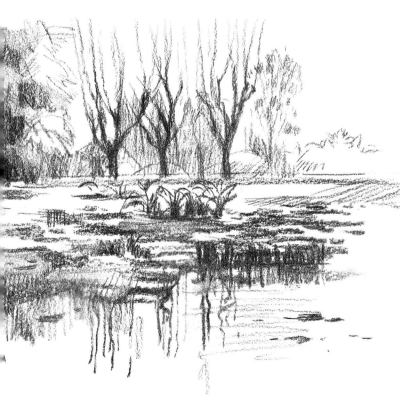

In this drawing you can see the greater darkness (emphasized by thick charcoal strokes) of the reflections in the water, compared to the actual objects themselves.

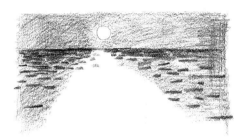

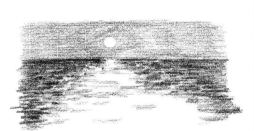

1. A general shading means making most of the drawing dark and leaving only the central angle in the light.

2. Short strokes, closer together in the area closest to the horizon, represent the ripples on the water.

Reflections are, of course, reflected light. You can see this clearly when the reflections are of white surfaces, such as walls. Note how the shape of the wall in the water is blurred by the ripples, which reduce the amount of light reflected on the surface of the water.

3. Make a few strokes on the lighted angle to make it appear more realistic.

The random shapes that appear on the surface of the water, where brightness and reflections blend together, are treated with great sensitivity in this drawing—but with enough rigor to make it realistic.

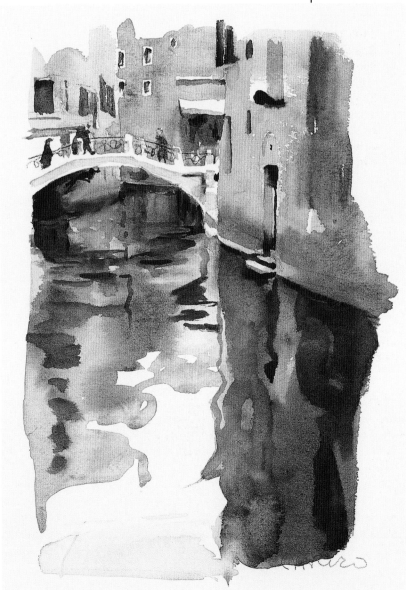

Selecting the Subject & Blocking the Landscape

A landscape is not a unit that can be captured in a single glance, but a constant panorama with no defined limits. The artist must create these limits by deciding which fragment, of the many before his or her eyes, is the most significant or the best-suited subject. Blocking, therefore, means to decide what the limits of the drawing will be, based on the principles of composition, and to consider the order and harmony of the various elements.

A QUESTION OF DISTANCE

To block a composition properly, it is essential to distance yourself from the landscape in order to really grasp its different facets. A wide panorama with few visual obstacles allows you to decide more easily which aspect is the most attractive. Normally, this means situating yourself at an elevation that allows you to take in a large expanse at a glance. Once you decide on your blocking, you have total freedom to augment, reduce, or eliminate any of its elements.

When choosing a part of the landscape to draw, look for a scene that contains a number of elements that are distinct from one another in terms of tone, shape, and size.

Your scouting location should give you a wide visual field. From a good spot, it is easy to identify different subjects and then block some of them. The best places tend to be at an elevation.

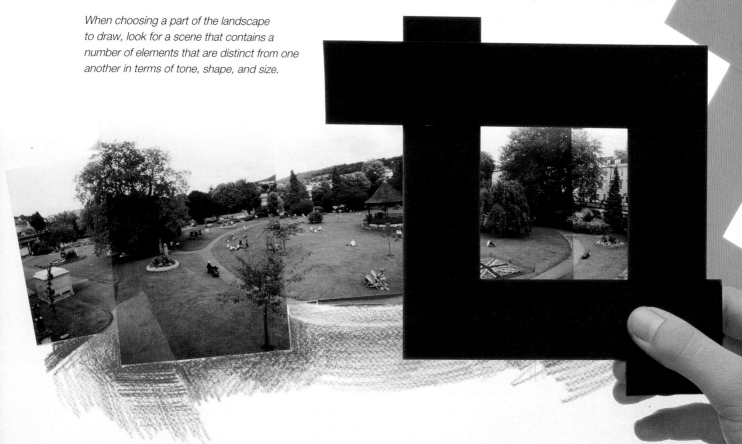

Horizontally blocked drawings generally contain more elements, so it is better if there are fewer sharp contrasts among them.

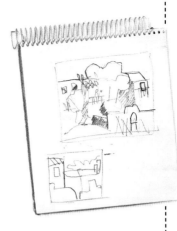

FORMAT & BLOCKING

The appeal of a work depends in large part on blocking, because every landscape has its own unique characteristic, a facet that makes the particular view more interesting than the rest. Depending on the landscape, your blocking can be vertical or horizontal, square or rectangular. The decision depends upon the elements you choose to depict: Isolated subjects, such as trees, or buildings, tend to be easier to block vertically, while horizontal framing favors a more expansive, deeper panorama.

Vertical framing lets you isolate particular elements.

Framing a landscape subject is synonymous with simplifying it. At first glance, the landscape is too rich in details and contradictory elements. It is necessary to suppress anything that takes away from the clarity of the work. To achieve this, make a few exploratory sketches of the same subject, reducing and simplifying the scene each time.

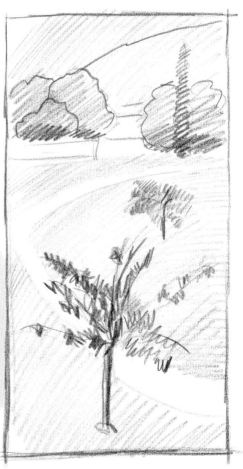

The Landscape from Your Point of View

Drawing any landscape, whether real or imaginary, implies a point of view in relation to the subject. The same landscape can be represented from many different points of view, some more favorable than others. Each point of view shows the subject through a different prism—so much so that each one can sometimes appear to show completely different landscapes.

HEIGHT

Any landscape will look different from different heights. The higher the painter is situated, the less important the particulars of the painting will be and the more important the composition of the whole. Details become unimportant from an elevated point of view, but at ground level they gain a relevance that can turn them into the focal point of the entire painting.

Sand dunes or beaches demand a ground level point of view. These subjects can be rendered using a few strokes, because there are few elements. Include something that breaks the horizontalness of the drawing—perhaps a lifeguard's chair or an umbrella.

An elevated point of view tends to suppress the details and give more importance to the extension of the panorama.

As the viewpoint descends, the point of view begins to include objects that are closer, while the more distant planes are diminished.

Finally, from a low vantage point, the objects in the foreground are clearest in the drawing, and the more distant planes all but disappear.

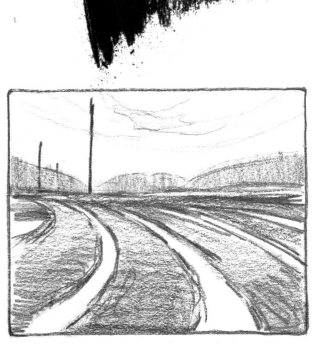

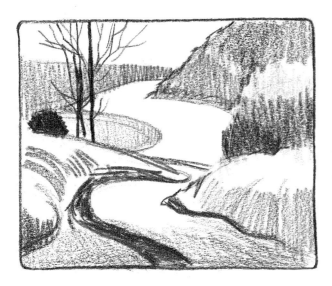

A vantage point level with the ground is more interesting if the landscape includes very busy profiles or several different levels.

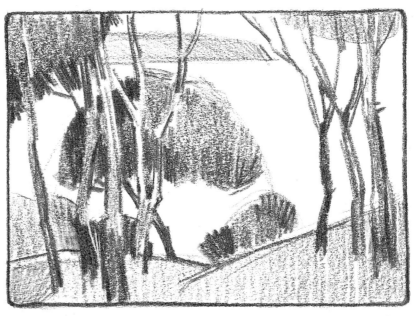

CHOOSING A POINT OF VIEW

Choosing a suitable point of view depends on the landscape. For very flat landscapes, a higher point of view tends to be the better option because the objects in the foreground are of little visual interest. For busy landscapes, assume a lower point of view in order to bring out the details of the terrain. But there are many exceptions: the artist may be interested in emphasizing the very flatness of the land and so will choose a low vantage point facing a plain. The important thing is for the subject to appear as a diverse, visually interesting whole.

This drawing has an elevated point of view (a hillside facing the sea) and a busy foreground. This combination produces great visual force.

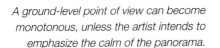

A ground-level point of view can become monotonous, unless the artist intends to emphasize the calm of the panorama.

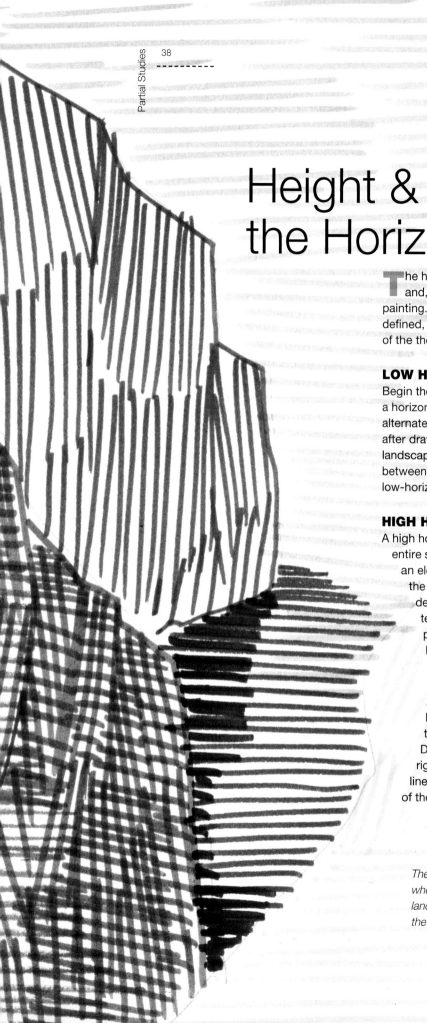

Height & Position of the Horizon

The horizon is a fundamental aspect of landscape painting and, in fact, almost every other kind of figurative painting. In the landscape, the horizon can be more or less defined, but it is always present, and it determines the depth of the theme and the entire composition of the drawing.

LOW HORIZON

Begin the spatial organization of your landscape by drawing a horizon line. A low horizon line does not allow you room to alternate between "layers," because you arrive at the sky after drawing just a few objects in the landscape. A landscape with a low horizon depends on the contrast between the size of the trees, hills, or buildings it shows. In low-horizon drawings, the sky assumes a very important role.

HIGH HORIZON

A high horizon allows you to develop your subject across the entire surface of the paper. It generally corresponds with an elevated vantage point and a steeply slanted view of the landscape. A high horizon tends to favor a descriptive style that individualizes every nuance of the terrain; it multiplies the number of objects in the picture and extends the view into the distance. The horizon can rise to the upper edge of the paper until it almost eliminates the sky altogether.

ADJUSTING THE HORIZON

Regardless of the artist's viewpoint, it is a good idea to avoid dividing the landscape in half on the paper. Dividing the drawing into two equal parts creates a rigid, static sense of symmetry. It is better to place the line of the horizon somewhat above or below the middle of the page.

The landscape might not have a horizon at all. This happens when you work from a very high vantage point and view the landscape from a steep angle, as in this drawing of cliffs by the sea.

Low horizons accentuate the objects in the foreground, and turn their shortened profile into the foundation of the composition.

High horizons considerably reduce the foreground by multiplying the number of objects in the drawing and extending the view into the distance.

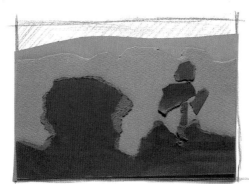

In landscapes with a low horizon, trees, hills, and buildings appear more monumental and can be seen in their entirety. This kind of landscape avoids grand, panoramic perspectives and is better suited to a long, horizontal format.

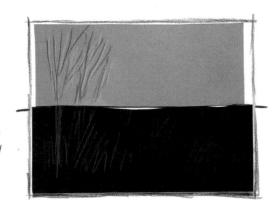

Even if your point of view dictates a centered horizon in your drawing, avoid placing it in the exact middle of the picture, which produces a rigid, static effect.

A centered horizon can easily be turned into a somewhat elevated horizon by simply moving the line slightly above the middle of the page.

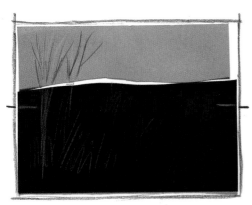

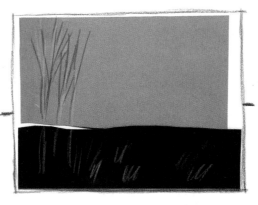

As an alternative to the previous example, drop the line of the horizon below the middle of the page. This will not alter the basic structure of your drawing significantly.

Points of Visual Attraction

Regardless of the subject depicted, every drawing must follow certain compositional constants that you should learn. They determine the visual effect of the work and can either make it more interesting or diminish its expressiveness. Using these tools is not a matter of applying a set of rules to every drawing; rather, it means observing certain principles which are always valid.

CROSSES AND VERTICES

Crossing lines always attract the viewer's attention. Bear this in mind to avoid undesired emphasis. Two crossing branches can be drawn a bit separated to avoid turning them into a center of attention. Vertices, or "arrowheads," also mark a specific spot in the drawing. Avoid them, unless the emphasis that they create is necessary to the subject you wish to represent.

CENTER AND EDGE

Viewers' eyes are always drawn to the center of the drawing. This means that a very "centered" landscape does not need much visual support, while a drawing whose center is blank forces the artist to heavily emphasize and darken the edges to compensate for the absence of a strong visual center. This illustrates a general principle: the center of the landscape should be less busy than the rest of the drawing.

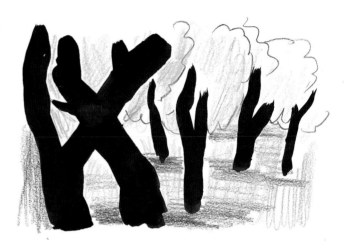

Crossing lines attract the viewer's attention immediately. This can be helpful or harmful to the drawing; understand this principal so you can use it wisely.

You needn't draw crosses, even if they appear in the landscape; a slight alteration of the direction of the branches or trees solves the problem.

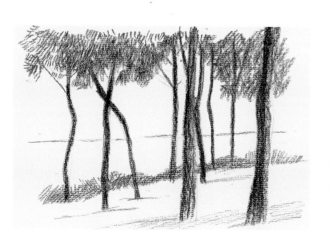

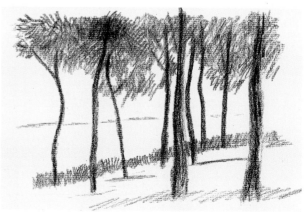

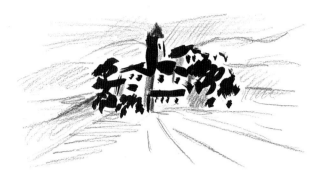

A very centered landscape hardly needs help to become the center of attention, because the viewer's eyes naturally gravitate toward the center of the drawing.

An involved drawing extends around an empty central space that gives meaning to the whole. The empty center is as important as the elements surrounding it.

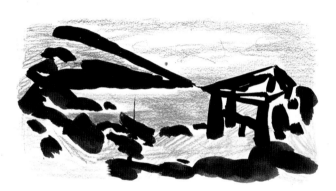

The point of visual interest created by opposing vertices does not mean a deviation from the central attraction; on the contrary, it guides the viewer's eyes toward the most distant points in the drawing.

The vertices of angles, and, especially, opposing vertices, create powerful points of visual attraction. Keep this in mind in order to avoid distracting the viewer's attention toward areas of secondary importance.

An involving drawing requires greater emphasis on the areas surrounding the center of the composition, to compensate for their secondary position.

Line Sketches & Outlines

Every landscape can be reduced to a simple compositional outline that summarizes its basic characteristics. Usually, these early sketches are made by arranging the basic lines of the subject in an orderly fashion on the paper, following the basic compositional principles discussed in the previous chapter: avoiding symmetry, adjusting the horizon line, attending to the natural path of the viewer's gaze, balancing weights, and so on.

The outline and composition of any landscape, when it works, hides a conscious or intuitive calculation of the arrangement of its elements. In this example, the tree is the visual center toward which all the essential lines of the composition point.

In this compositional sketch, the landscape is reduced to its essential surfaces; each one of these outlines points in a single direction, and the largest tree is the visual center.

This sketch allows you to see how the visual center lies slightly right of center in the drawing.

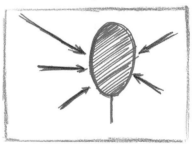

Many of the basic lines in the composition point toward its visual center.

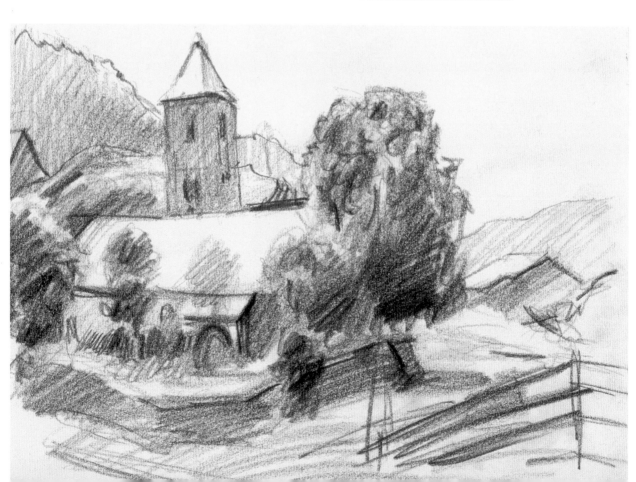

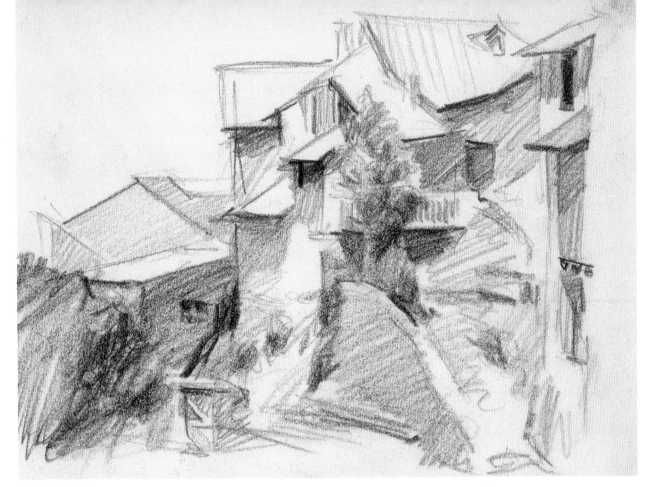

In landscapes in which architecture plays an important role, a compositional outline based on straight lines is easy to achieve, because these lines correspond precisely to the outlines of the buildings.

PROFILES & DIRECTION

The shapes in a landscape can be reduced to a cluster of simple profiles created by straight and curved lines. As you work, move from the simple to the complex. Do not include any details in the drawing until you have arranged the most significant outlines of the objects you want to draw on the paper. Furthermore, these outlines should have as a reference a center of interest, such as a tree, a cloud, a building, or some other object. This way, you create a hierarchy in the drawing as opposed to a mere gathering of strokes.

GROUPING & SCATTERING SHAPES

The center of attention in a drawing should not be situated in the center of the drawing itself, because this is where the viewer's eyes tend to gravitate in the first place; by placing the center of attention a bit to the side, you can balance the painting and make it more pleasant and attractive. Following the normal path of the viewer's line of vision, the most logical place for the "center" is somewhat left of the true center of the page.

This drawing shows the compositional outline implicit in the drawing above.

Here, too, there is a visual center—the tree—toward which some of the more important lines in the composition point.

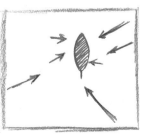

This outline shows how the direction of many compositional lines point toward the visual center of the drawing.

Every landscape subject hides a precise and simple compositional outline upon which all other aspects of the subject are arranged, whether the scene is complex or simple. Every experienced artist has marked leanings toward certain subjects, usually precisely those that fit his or her approach to composing and organizing shapes and strokes on the page. Diagrams help you to understand the essence of the subject and guide the work at each phase.

Compositional Diagrams

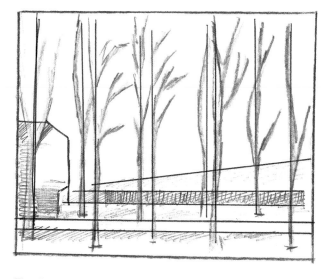

The diagram of this landscape is based on the perpendiculars formed by the trunks of the trees. This kind of composition is particularly static and serene.

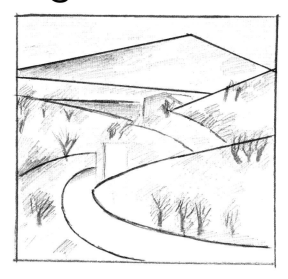

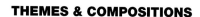

Compositional diagonals guide the viewer's eyes toward the farthest points in the landscape, creating a sense of depth.

Large compositional lines can start from an isolated element that organizes the entire landscape.

THEMES & COMPOSITIONS

Different landscapes suggest different compositional arrangements. Arrangements based on perpendicular lines produce solid, stable results. Compositions in which the dominant features are angles and diagonals suggest depth with greater force; diagrams based on curves and spirals, on the other hand, provide energy and variety. Any landscape can suggest one or another of these alternatives. The important thing is to favor only one of these possibilities and ignore the rest so that the resulting work is a unified whole.

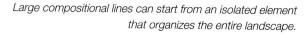

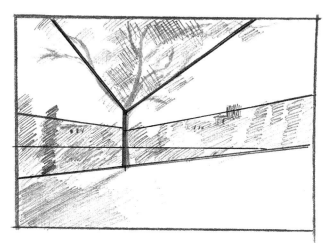

SKETCHES & APPROXIMATIONS

Artists often make many, many sketches and compositional studies of the different possibilities a given landscape provides. Usually, the right diagram doesn't happen on the first try, and you must make several more attempts through quick sketches, many of which can be valid works in themselves.

The composition of some landscapes can be based on unusual diagrams, such as this spiral line. Like diagonal diagrams, these too create a sense of increasing depth, but in an even more dynamic way.

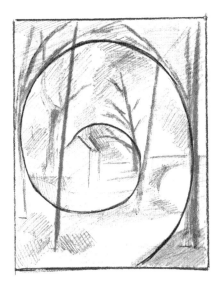

Studying the composition of a single landscape can yield many variables, each of them centered on only one of its aspects.

The essential lines of a composition can begin at one of its elements, such as this composition, drawn from the outline of a tree.

The study of a composition offers many possibilities, such as organizing the outline around the masses in the landscape.

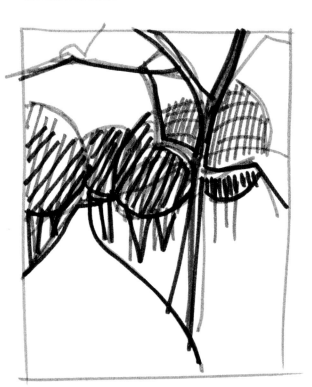

Shadows & the Direction of Light

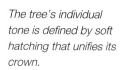

Shadows are a product of light and vary according to its quality, intensity, and direction. In a landscape, these factors affect countless different elements, which are difficult to isolate and study individually. The images on this page show just one of these elements, how it is affected by the direction of the light, and how it can be rendered using simple shading.

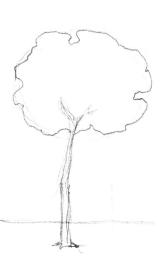

The contours of this tree are created by first making a simple, oval outline that allows you to draw the profile of the tree in the correct proportions.

The study of shadows is easier when the masses of these trees are reduced to their bare contours and differentiated by their individual tones. Later, you can alter the tones using shading.

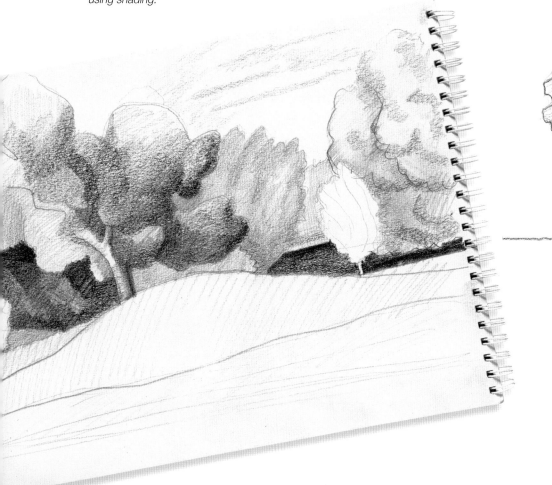

The tree's individual tone is defined by soft hatching that unifies its crown.

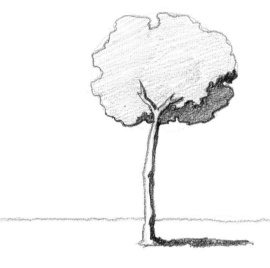

Lighted from the side, the tree casts its shadow primarily on the lower part of the side away from the light source, and the shadow it casts is short.

THE INDIVIDUAL TONES OF OBJECTS

Every object has its own individual overall color or tone, lighter or darker depending on the light. Shade the object based on this tone, then make it lighter or darker as needed. Thus, the initial shading in a drawing should be generic, made according to the individual tones of each object. Only then can the actual shadows be added.

CAST SHADOWS

The individual shading of an object is produced by light falling on its volume. The shadows the object casts are projected onto other objects. When lighted from the side, this tree displays shadows on the side opposite the side that is lighted, and the shadow it casts is rather short. Lighted from above, the same tree "gathers" its own shadows on its underside and casts a shadow that stays close to its base. When the sun is going down, the shadow the tree casts is longer, while the shadows on the tree itself become dense on the side away from the sun.

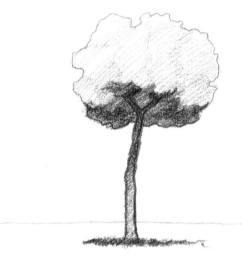

Lighted from above, the tree casts a shadow centered around its base. Notice how this lighting creates a relief affect between the trunk and the crown.

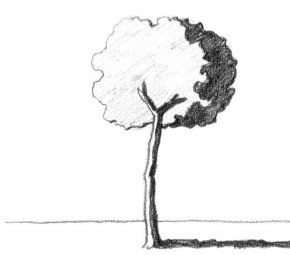

Lighted when the sun is very close to the horizon, the tree casts its shadow a long distance and the shadows within the tree itself grow deep, covering the entire side of the crown.

Basic Shading Techniques

The simplest way to approach shading in landscape drawing is to include the limits between light and shadow, defining the shaded areas with total precision. The contrast between the dark tones of the shadows and the color of the paper is enough to create the illusion of depth. This perfect definition is seldom found in the landscape itself, though in the late afternoon on a clear day, shadows may appear with great definition and clarity.

CONTRASTS

The basic contrast in shading is established by the tone of the paper (whether white or colored) and the tone created by the drawing media (pencil, charcoal, red ochre pastel). If the contours that define the borders between light and shadow are drawn clearly, shading will be as easy as spreading a gray tone using looser or tighter strokes, depending on how dark you want the tone to be.

2. The compositional outline gives way to a more detailed outline of the landscape's contours. Thanks to the simple initial outline, it is much easier to arrive at the more developed line drawing with confidence in the correct proportions of the composition.

1. This example of basic shading will be made using charcoal pencil on cream-colored paper. First, define the basic lines of the composition: the horizon (the top line), the shapes of houses and trees (the center line), and the shadows cast by the objects (the lower lines).

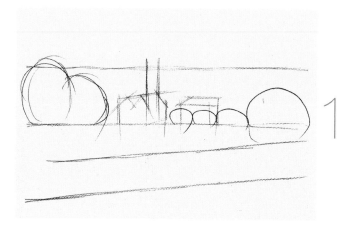

3. The next step is to define the limits of the most significant shadows in the drawing. In the afternoon sun, light and shadow are differentiated with complete clarity.

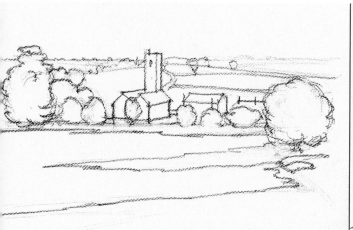

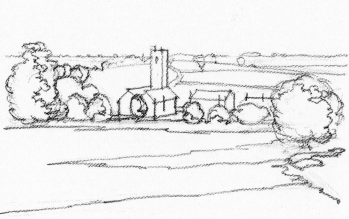

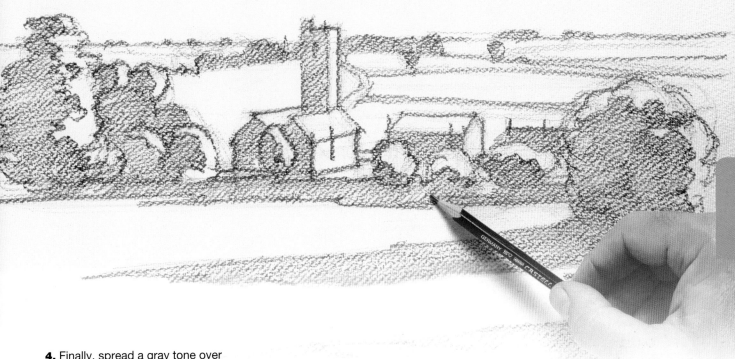

4. Finally, spread a gray tone over the areas reserved for shading. The hatching should be done in diagonal lines to achieve a uniform gray tone that contrasts with the lighted parts of the drawing.

DRAWING SHADOWS

Drawing shadows is very much a part of the composition of the landscape. This composition allows for a fairly precise line drawing as well as clear definition of most of the elements in the landscape. By recognizing light and shadow early in the drawing process, you will find it much easier to grant each element its own precise lighted and shaded areas. If the drawing is well constructed, the basic shading is simply a matter of filling in the areas earmarked for shadow.

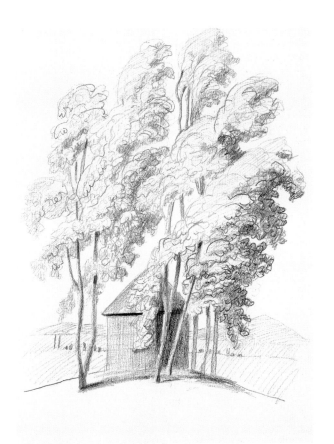

Some subjects allow you to distinguish quickly between lighted and shaded areas, creating a few gray blocks that can be rendered in just a few strokes.

Value & Tonal Gradation of the Landscape

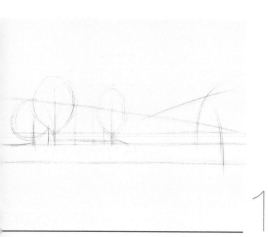

1. The compositional outline consists of two or three horizontal lines representing the boundaries of the landscape, plus a few softly sloping diagonals that situate the mountains in the distance. The outlines of the trees are made with the usual oval shapes.

1

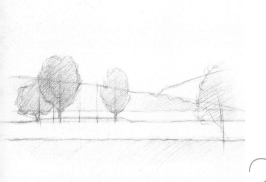

2. In order to grade the tones in a drawing, you must start with a very light tone to cover the most important shapes. Later, search for new, darker tones that add subtlety and depth.

2

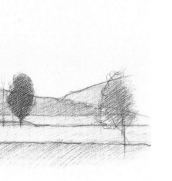

3. The darkness of the trees makes them stand out against the background. Notice that there is no shading here per se, only a tonal gradation that allows us to distinguish the different shapes in the drawing.

3

Shading is the application of a contrasting tone that allows you to represent the light and the general relief of the landscape. Usually, the tone will not be uniform. Rather, several different tones are required to render the shadows. This is called the tonal gradation of values of light and shadow. The contrast between these values makes the drawing richer, more nuanced.

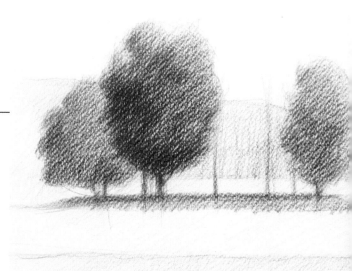

DETAIL & NUANCE IN SHADING

Shading in a single tone does not allow for nuance; the different lights in the drawing appear to have uniform clarity and the shadows all have the same gray or black tonal value. The use of different tonal values lends the drawing subtlety and precision, creating details in shaded areas and helping to distinguish the different aspects of the element.

USING TONAL GRADATION

As with shading, the tonal scale in a landscape drawing should begin with a good compositional outline that organizes every shape in the composition on the paper. From there, proceed to drawing the contours and the definition of the most significant silhouettes. The shading is no longer created by defining the borders between light and shadow, but by distinguishing between shadows through your use of shading, so that the darker areas are distinguishable from the lighter ones by their greater intensity.

The values used in this exercise are four different tones of the same color—a Prussian blue pencil.

You don't need a large number of different tonal values in order to express the essence of a landscape. Two gradations of gray are enough to achieve a satisfactory representation. In fact, when making a sketch in ink and brush, artists tend to use only two or three tonal values.

4. Finally, shade in the lower part of the tree crowns to represent the specific lighting of your subject. Some slightly darker tones add to the depth of the mountains in the background.

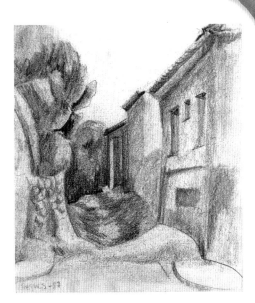

The use of a sufficient number of tonal values allows the artist to depict not only the light and shadows in the landscape, but also the depth and shape of each element.

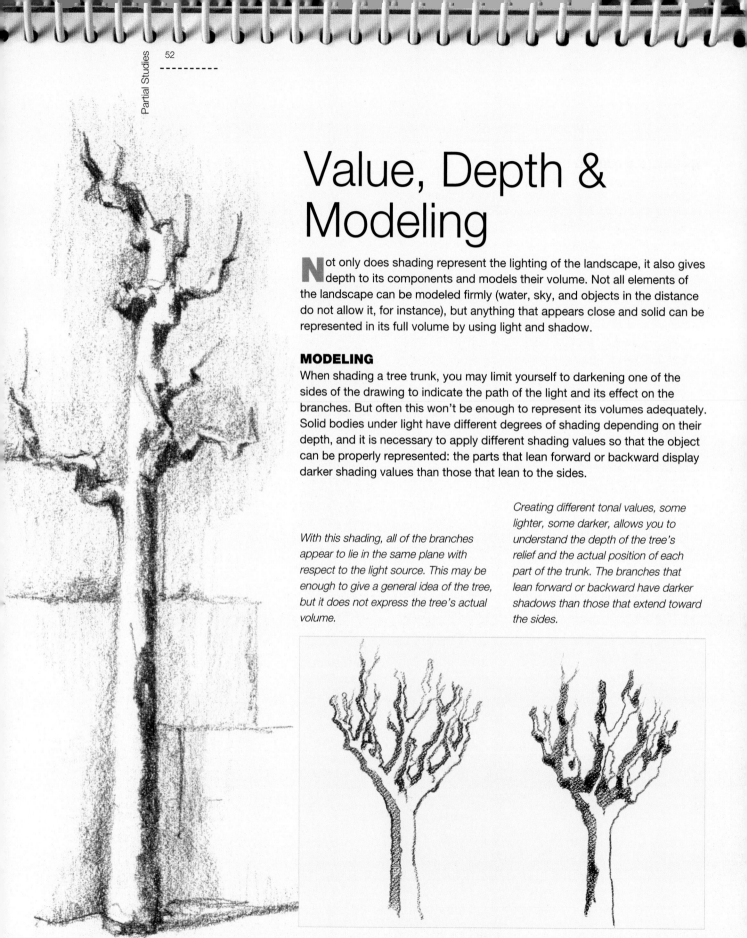

Value, Depth & Modeling

Not only does shading represent the lighting of the landscape, it also gives depth to its components and models their volume. Not all elements of the landscape can be modeled firmly (water, sky, and objects in the distance do not allow it, for instance), but anything that appears close and solid can be represented in its full volume by using light and shadow.

MODELING

When shading a tree trunk, you may limit yourself to darkening one of the sides of the drawing to indicate the path of the light and its effect on the branches. But often this won't be enough to represent its volumes adequately. Solid bodies under light have different degrees of shading depending on their depth, and it is necessary to apply different shading values so that the object can be properly represented: the parts that lean forward or backward display darker shading values than those that lean to the sides.

With this shading, all of the branches appear to lie in the same plane with respect to the light source. This may be enough to give a general idea of the tree, but it does not express the tree's actual volume.

Creating different tonal values, some lighter, some darker, allows you to understand the depth of the tree's relief and the actual position of each part of the trunk. The branches that lean forward or backward have darker shadows than those that extend toward the sides.

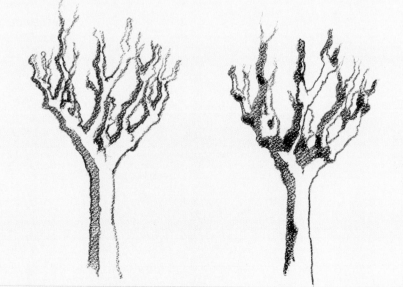

SHADOW & DEPTH

Low lighting promotes a more intense sense of depth or relief than direct sunlight, and all of the surfaces that it covers appear more textured. This is especially visible on rocky landscapes or landscapes that include buildings: the faces of rocks or walls that receive direct sunlight appear flatter than those that take in light from the side. The depth of these surfaces should be rendered carefully, with close attention to the entire play of tonal values that they have to offer.

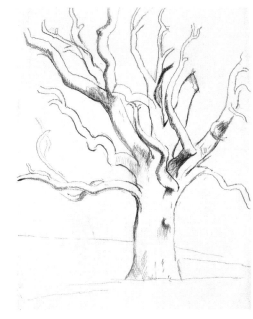

Adequate tonal gradation produces a clear representation of relief, depth, and texture and establishes the space of the drawing. The tonal gradation reflects the distinction between shapes that appear to lean toward the viewer and those that appear to be receding.

To achieve a three-dimensional effect, play with the tonal values of the shadows in the drawing. Even in drawings with very little shading; a few well-placed shadows are sometimes enough.

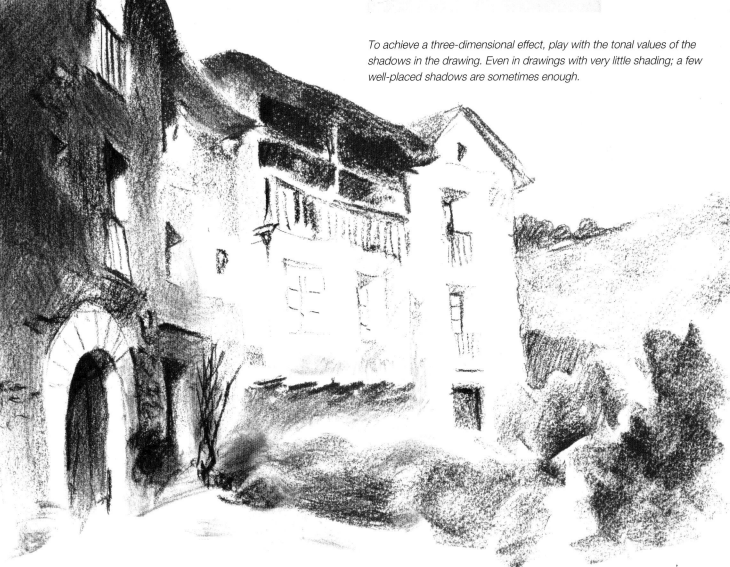

A B C D

Tonal Value & Drawing Media

Tonal gradation and shading can be done in any medium, but the results are very different depending on the medium you choose. Generally, the greater the density your drawing instrument allows, the greater its tonal register will be, allowing for a greater number of values. This page shows the same drawing of a tree made in different media, each of which has a distinct tonal register.

USING LEAD

The lead of a mechanical graphite pencil can be hard or soft. The harder the lead, the lighter the stroke it produces. There are somewhere between fifteen and twenty varieties of lead hardness. These illustrations show a drawing made with a very hard lead, another with a medium lead, and a third with a very soft lead. The differences are considerable, and most artists prefer softer leads because they have the broadest tonal register. Charcoal lead produces a much more intense stroke than pencil or even red ochre pastel or charcoal sticks; nonetheless, its tonal register is more limited than that of pencils, because it is harder to produce truly tenuous strokes.

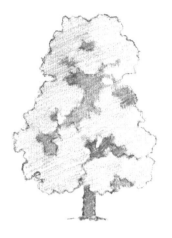

Harder lead offers a very soft, limited tonal register. It is impossible to produce truly dark tones with it, but it is useful for producing delicate strokes.

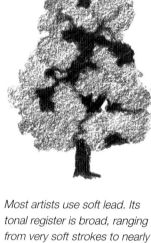

Most artists use soft lead. Its tonal register is broad, ranging from very soft strokes to nearly black shadows.

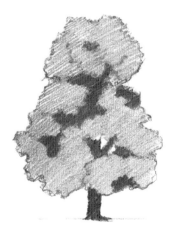

The tonal register of medium lead is somewhat more textured than hard lead and can produce darker tones, although it never quite approximates a black tone.

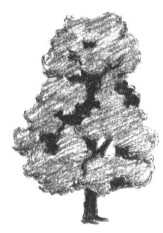

Red ochre pastel, in stick or lead form, produces a red tint that can be used to obtain a wide array of tones.

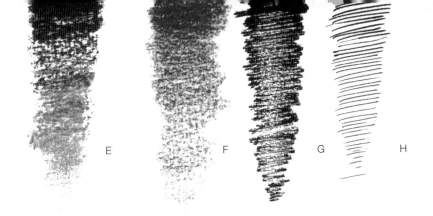

E F G H

From left to right, the different intensities that can be produced by using hard lead (A), medium lead (B), soft lead (C), charcoal pencil (D), charcoal, graded with a stumping pencil (E), red ochre pastel (F), ink and reed (G), and pen and ink (H).

INK

Ink is the darkest drawing medium. This doesn't mean that its tonal register is very broad; on the contrary, the tone of its strokes is unchanging, always a dark, dense black. The only way to vary its intensity is through the density of your strokes or by using solid blocks of ink or black spots. There is also a difference between ink drawings in pen and those made with a reed. The former has a fine, uniform stroke, whereas the latter produces a thick stroke that changes depending on how much ink is on the tip.

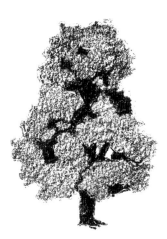

Charcoal pencils produce much deeper blacks than any pencil, but they are not good for producing very soft strokes.

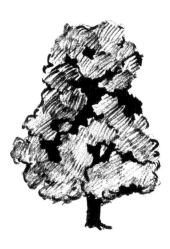

India ink can be applied with a reed, which produces a thicker stroke that can vary depending on how much ink is on the tip.

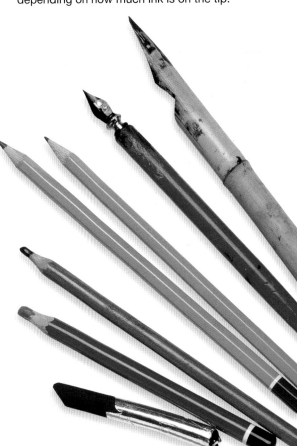

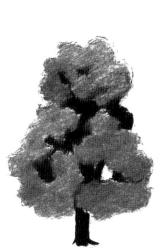

Although the black pigment in charcoal sticks is not as profound as it is in charcoal pencils, charcoal has many more possibilities. Charcoal stains can be blended or "stumped" into many different shades.

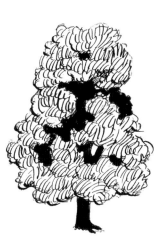

Pen and India ink always produce the same tone; tonal variation can only be achieved by varying the density of the hatching.

Shading with a Stumping Pencil

Stumping is a common technique in charcoal drawings. It basically means blending strokes by grading their intensity from light to dark or vice versa. Stumping fades the outlines of objects and introduces an atmospheric chiaroscuro effect appropriate for several different kinds of landscapes. Using this technique, surfaces appear without sharp edges, ensuring the unity of the drawing and the representation of depth is achieved easily.

A. No matter how dark and dense a charcoal mark is, it can always be reduced until it almost disappears amid the blur of the stumping.

B. To reinforce the darker tonal values, layer charcoal pencil marks on the charcoal spots without using the stump.

C. To achieve the rippling effect in the water, apply parallel marks and then use the stump to blend them into one another.

D. An eraser can be used to create the effect of lighted clouds by cleaning the upper part of the charcoal spot.

E. The reflection of the sun on the water is achieved by erasing part of the charcoal spot, so that the strokes of the eraser are visible.

F. Like the reflection in the water, the most luminous part of the sky is rendered by erasing the charcoal, then applying some white chalk strokes.

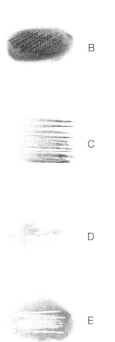

A

B

C

D

E

F

Landscapes based on stumping techniques possess an incomparable atmospheric quality. For this reason, charcoal is commonly used to create the effect of soft light at dusk or dawn.

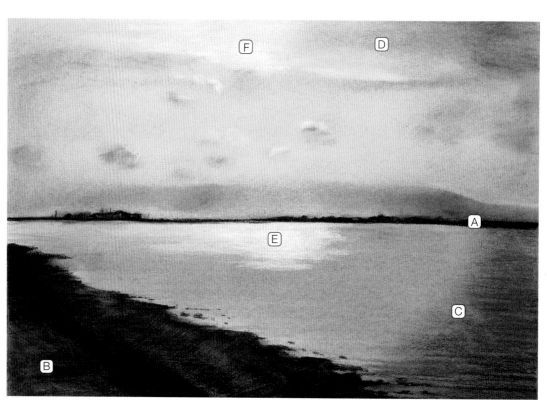

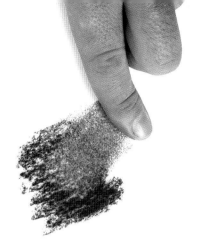

A clean rag or, even better, your fingers are perfect blending or "stumping" tools. Your finger is the best option when dealing with fine detail work.

When lead or charcoal pencil is your only medium, your blends will not be as subtle as they would be in charcoal stick. To compensate, use soft strokes that contrast with the more intense strokes of the charcoal.

THE PROCESS OF STUMPING

With a charcoal drawing, the initial outline can be made with the charcoal itself because its marks can be easily erased. The spots in the drawing are very loose, and tonal values can be adjusted by modifying their intensity using your fingers or a cloth. You can also use your finger or a cloth to achieve the blending or "stumping" effect, which in very detailed drawings can then be complemented by using a stumping pencil.

BLENDING

There is no secret to blending two charcoal marks into each other. It's as easy as rubbing your finger or a cloth over them. An eraser is helpful in the final stages. When you are using charcoal, the eraser lets you clean off the paper to obtain lighter tones, and also allows you to correct your mistakes. In fact, the eraser is another drawing medium. If the paper is white, the eraser allows you to lighten the shading until it is as light as possible.

Charcoal and white chalk yield the best results on colored paper, especially when the paper is a light color.

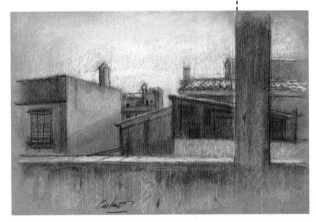

An eraser is indispensable for any charcoal drawing: not only does it serve to correct your mistakes, but it can also be used to reveal the natural tone of the paper in the more lighted areas of the drawing.

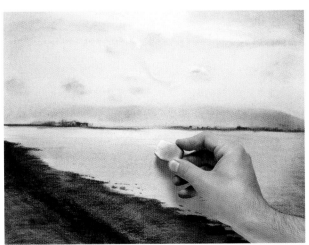

A white chalk pencil is very useful for creating more light—apply it to a lighter area of the drawing. You can only do this when the paper is completely white, as it is here.

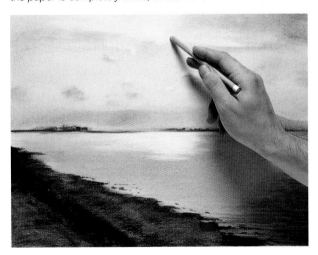

Tonal Value & General Shading

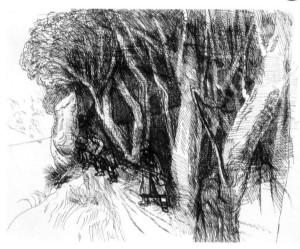

Dense shadings in ink create swaths of very different tonal values in which the outlines of shapes blend into one another and shapes are not clear-cut. The result here neatly expresses the dense darkness of a forest.

Regardless of the medium you choose, the relationship between different tonal values should result in a general shading that reflects not only the lighting but also the position of every element in the space of the composition. Elements that are closer can be "foregrounded" by applying a different intensity to the strokes that define them. Or you can get similar results by using unusual tonalities.

GRADATION OF TONAL VALUES

The gradation of tonal values is a function of how elaborate the work is . Generally, this gradation will be more extensive the greater the degree of detail desired. But it would be a mistake to add excessive gradations in an attempt to add nuance to every detail; too much gradation of tonal values leads to confusion and a loss of visual force. Every drawing should contain tonal values of clearly greater intensity that contrast properly with the rest. Usually, the foreground displays greater contrasts, and objects in the distance should be shaded more softly.

SILHOUETTES AND CONTOURS

In a heavily shaded drawing, silhouettes and contours are revealed by a contrast in their tones—light against dark, or vice versa. In these cases, lines are extraneous because boundaries are defined by the contrast between different tones. It is a good idea to have shapes fade slightly in certain areas and blend into neighboring shapes to give all of them a uniform atmosphere. The whole landscape will appear to be bathed in the same light, ensuring the unity of the drawing.

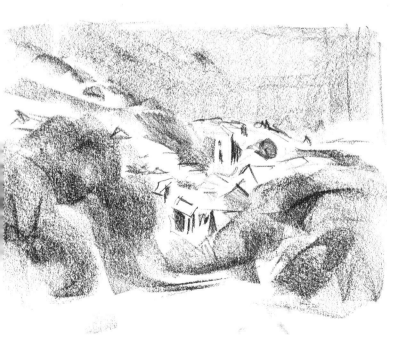

Even when working without dense shading, it is possible to diversify tonal values by combining different strokes and drawing instruments. This drawing was made using pencils, red ochre pastel, and charcoal pencil.

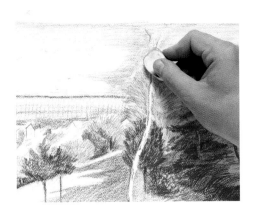

A gum eraser can be used to reduce the intensity of a tone created with strokes of a colored pencil.

This drawing was made using a red colored pencil to show that even less common media can provide a sufficient range of tonal values if they are used to their full potential.

A. Softer strokes were used for the sky. To add nuance to this tone, rub the eraser over some of the areas, leaving a trace of color on the paper.

B. To add texture and force to the foreground, add small, dashlike strokes to a dark hatching.

C. The foliage here was rendered using a zigzagging stroke and by layering very dark, additional strokes.

D. The lighter parts of the foliage were rendered with a quick application of pencil in zigzagging strokes.

E. The shadows cast on the meadow are rendered with masses of very tight strokes, so that the individual lines become indistinct.

F. In the distance, the shadings are more subtle, barely changing the white of the paper.

You can also obtain different tonal values when working with colored ink by reinforcing the light and dark areas of the drawing. The layering of strokes makes these contrasts possible.

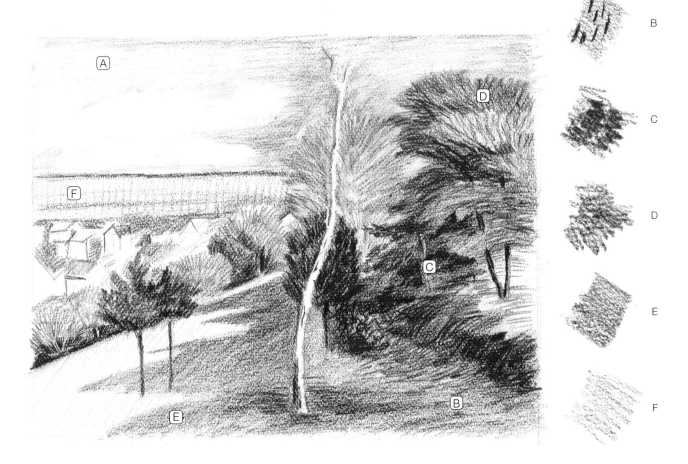

A

B

C

D

E

F

Shading with Hatching

When using drawing media with fine lines, shading becomes a particularly labor-intensive task, because the creation of different tonal values depends on a systematic layering of strokes. The denser the hatching, the darker the tonal value of the corresponding shadow. Although hatching can be done in graphite pencil or with thicker media such as colored pencils, shading with hatching is usually associated with pen or reed.

HATCHING LIGHT TO DARK

Like any other shading technique, hatching progresses from light to dark tonal values. When working in pen or reed, it is very important to begin with a preliminary composition and a study in pencil of the hatching that will come into the picture—remember, there is no way to lighten darker tonal values by erasing. Then, using pen or reed, you layer the hatchings patiently, superimposing lines on all parts of the drawing.

VARIETY IN HATCHING

Although it is perfectly fine to apply the same kind of hatching throughout the drawing (crosshatches, arrow shapes, ring patterns), the result will be more attractive if you combine different hatching styles. Each of these styles is applied depending on the surface that needs to be graded. Thus, flat surfaces such as walls or facades can have a straight, perpendicular crosshatch, while more irregular surfaces such as trees and vegetation in general can be hatched using rippling effects.

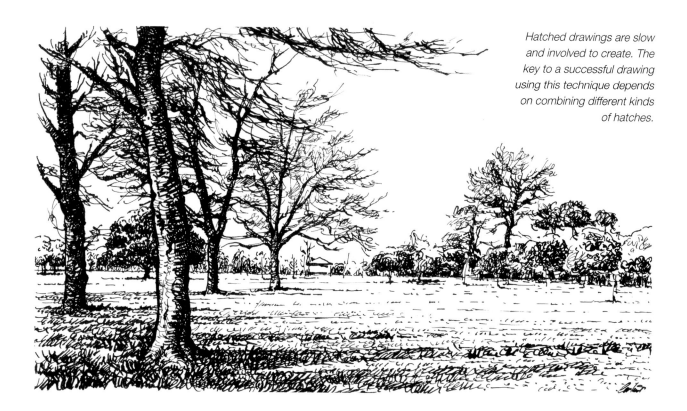

Hatched drawings are slow and involved to create. The key to a successful drawing using this technique depends on combining different kinds of hatches.

1. Every drawing to be hatched in pen should begin with a firm compositional outline in pencil. Here, the trees and buildings are sketched and arranged using simple shapes.

2. The initial drawing in pencil can include tentative hatches, using different kinds that can later be erased in the finished drawing.

3. This drawing was created using a single pen. The different hatches are adapted to the surfaces that they define, gathering most densely in the more shaded areas.

A. Rippling, vertical hatches allow you to represent the characteristic look of cypress trees.

B. The zigzagging lines here produce a convincing version of the foliage of olive trees. These lines barely form hatches, in contrast with the darkness of the tonal values in the center of the drawing.

C. The tops of these trees are rendered using hatches made up of very short strokes that follow an oval trajectory.

D. The trees flanking the cypresses in the middle of the composition are created from hatching that resembles a cloud shape.

E. Layered horizontal lines are used to achieve darker tonal values in the foliage.

F. The shading of these trees is accomplished by adding hatches that run parallel to the earlier, curvilinear shadings.

G. The shading of the umbrella pine tops also shows an application of parallel horizontal hatches to reinforce the texture hatches of the foliage.

H. The facades here show a hatching much different than the ones used for the trees. They are based on crosshatching, the crossing of vertical and horizontal lines.

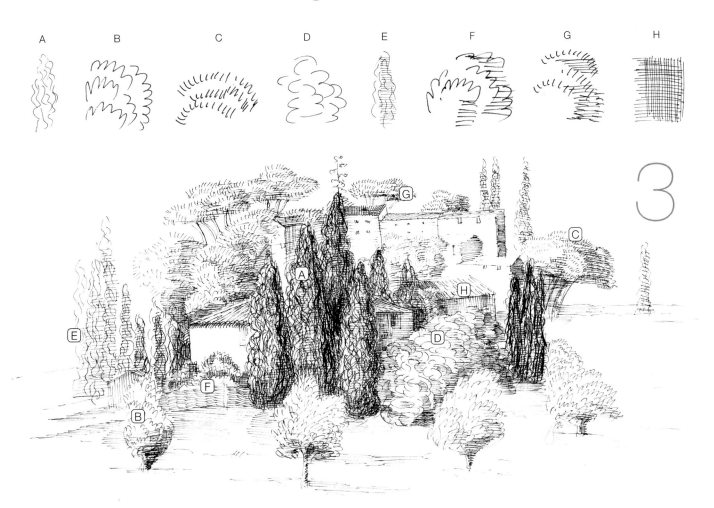

A B C D E F G H

Contrast & Three-Dimensional Shapes

Many landscape elements must be treated as three-dimensional shapes with closed contours and a volume of their own. To achieve this three-dimensionality, arrange the contrasts in the drawing in such a way that some parts appear to lean toward the viewer while others appear to recede. As all lighted areas tend to lean toward the viewer, the viewer will interpret shaded areas as receding. By keeping this in mind, you can model the more defined volumes as simple, regular shapes.

1. Reduced to their barest form, the volumes of a tree can be drawn as ovals of different sizes and shaded as if they were flattened spheres whose most brightly lighted areas are closest to the viewer.

2. When shading these "spheres," keep in mind that the shapes represent foliage. Add the necessary details to make it appear realistic. Still, the modeling obeys the logic of spherical volumes.

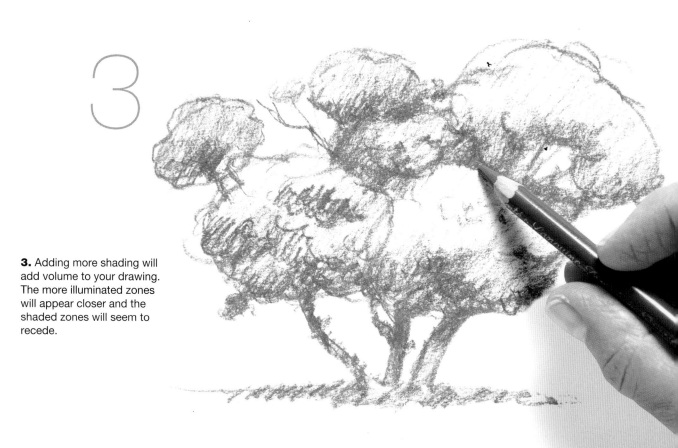

3. Adding more shading will add volume to your drawing. The more illuminated zones will appear closer and the shaded zones will seem to recede.

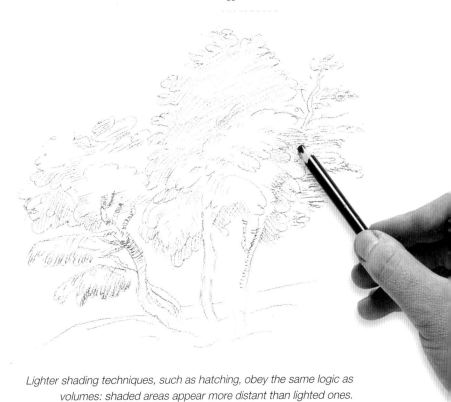

This study shows the principle that guides the effect of three-dimensionality through contrast.

Lighter shading techniques, such as hatching, obey the same logic as volumes: shaded areas appear more distant than lighted ones.

SPHERES & ELLIPSES

Bushes, treetops, and rocks can be outlined as ellipses or spheres whose regular volume distributes light and shadow precisely. Generally, light in a landscape comes from above, and these shapes are brightest on the very top. By shifting this light toward the center of the shadow, you can achieve a more volumetric effect.

SHADOWS RECEDE

Lighted areas are interpreted as being closer to the viewer, while darker areas appear to recede. When you move the light toward the center of the shape, the shapes assume a bulkier, more three-dimensional appearance. This principle applies no matter what shading technique you use.

You can achieve a rich spatial arrangement of the objects in a landscape by complicating the volumes. The darker shadows appear more distant than those with slightly less shading, and the lighted areas appear to be closer.

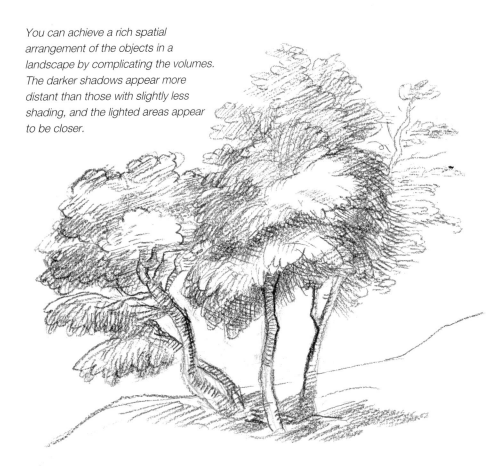

Contrast & Color

When we talk about contrast in the drawing, we consider the juxtaposition of light and dark tones. But contrast can also incorporate a chromatic element that, without taking away from the light and shadow, can enrich and enhance the drawing. If you wish to use different colors in a drawing, the usual approach is to opt for colors within the same range, cool or warm, which harmonize well together and do not produce discordant effects. Still, there is nothing to stop the artist from trying other, riskier possibilities.

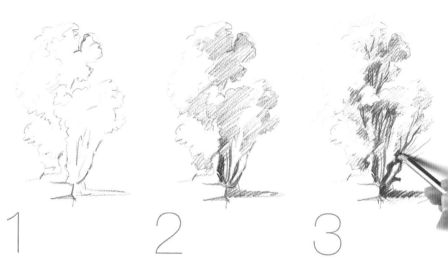

1 2 3

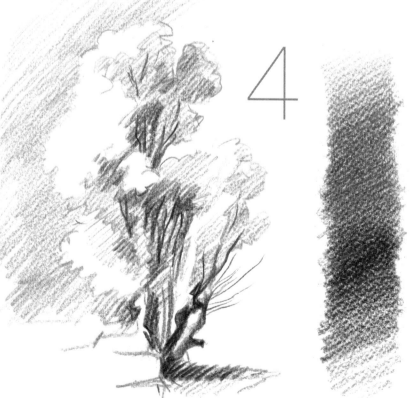

4

1. Any two-color drawing begins, logically, with a pencil sketch in the lighter of the two colors—in this case, a reddish ochre. The contrasting color will be a sienna.

2. The sienna is used to block the shaded areas with fairly loose parallel strokes. This creates an initial general contrast that establishes the basic harmony of the drawing.

3. The darker emphases help create a sensation of depth, which is reinforced here by a light darkening of the background in the places where the leaves of the tree are most lighted.

4. This is the final drawing, and, next to it, a gradation that blends the reddish ochre color with the sienna. These two colors are a perfectly harmonic combination, ideal for any landscape drawing.

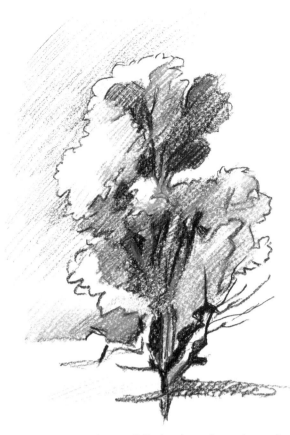

The use of contrasting warm and cold colors guarantees vitality and freshness in your sketches. Here you can cheerfully disregard the rules (with excellent results) by placing the colder colors in the foreground and the warm colors in the background.

Another warm-color possibility is using yellow ochre and sepia. The effect is brighter and more luminous, with more room for middle tints and a greater emphasis on the tonal scale.

SIMILAR TONES

Traditionally, landscape drawing uses one or, at most, two different colors, usually in warm colored pencils, because these are more certain to produce successful results. The images on these pages show the same drawing rendered in different combinations of paired colors, most of them earth tones—ochres, siennas, reds, and sepias. These colors are pleasant and also facilitate contrasts, for one of the colors is always palpably darker than the other.

CONTRASTING TONES

Some contrasting colors yield very nice, harmonic results at the same time that they sharply distinguish light from shadow. When such tones are used, the color of the paper is brought to the fore as nuances appear in the shadows. As an exercise, try riskier combinations, such as orange and blue, which tend to create warm lights and shadows that are not too cold.

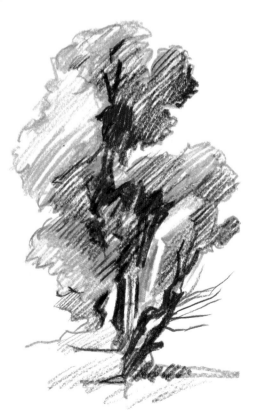

The color combination below, moving from yellow-orange to blue, is a warm color palette—perfect for southern Mediterranean landscapes that require strong, bright sun.

Perspective is a useful tool for representing reality faithfully, and it is essential in technical representations in engineering or architecture. However, most problems in perspective that a landscape artist encounters can be solved using his or her experience and intuition of the distances and sizes in a drawing. A drawing in perspective with a single vanishing point can provide the basic guidelines for every other case.

The Drawing in Perspective

HORIZON, VANISHING POINT & VANISHING LINES

To construct a proper perspective it is necessary, first of all, to draw the horizon line, whether or not it is visible in reality. Then you mark the position of the vanishing point, which defines the convergence of vanishing lines; these lines correspond to rooftops, cornices, sidewalks, and other rectilinear elements. The vanishing point is located at the spot where the extensions of these lines reach the horizon.

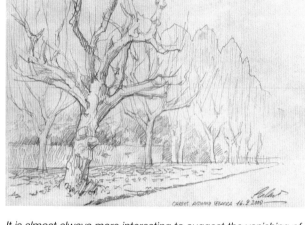

It is almost always more interesting to suggest the vanishing of the perspective than to draw every one of its details.

In most subjects in which linear perspective is actually present, other factors intervene that do not allow for its total extension. Here, trees and vegetation interrupt the complete development of the vanishing lines.

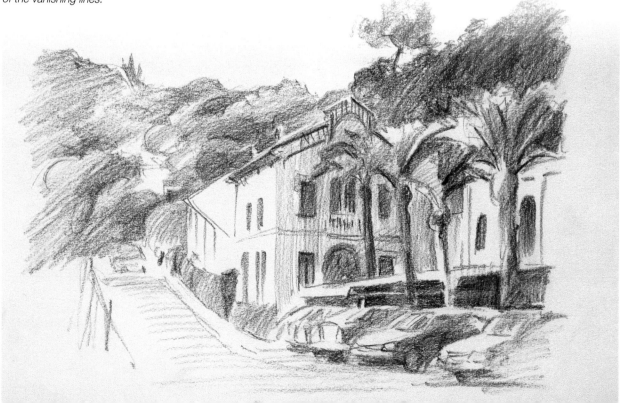

1. In this perspective, the vanishing lines correspond to the ideal edges of the porticos in a city square. These vanishing lines will coincide at a point in the horizon—the vanishing point.

2. On the spaces marked by the vanishing lines, we draw the architectural elements and the openings of the porticos. The spaces become narrower and more reduced the closer they are to the vanishing point.

3. The arches that give shape to the porticos can be interpreted as the arcs of a circle, and represented by oval shapes.

BUILDING ON VANISHING LINES

Vanishing lines are useful for arranging spaces in depth. By drawing vertical lines, it is possible to suggest doorways (which become narrower the farther they are from our point of view), windows, and any other space that is aligned with the vanishing lines. When the spaces are not square or rectangular, pay special attention to them. This is the case with arches that appear oval-shaped in perspective. The linear skeleton can then be covered with different details, lights, and shadows.

4. Once all the spaces are drawn and properly arranged, the drawing can be "dressed" with lights and shadow.

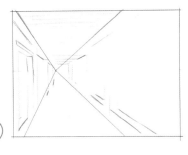

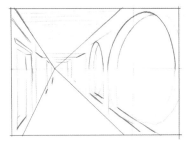

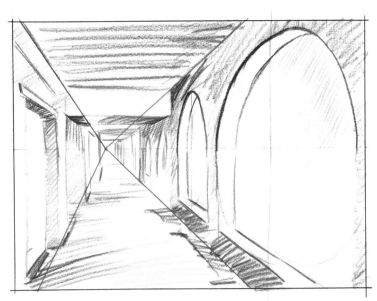

Streets and avenues often do not follow a straight path toward the vanishing point. The presence of curves or changes at ground level breaks the perspective's regularity and lends animation and appeal.

Arches follow the perspective rules of circles and become like ovals. You do not need to be able to draw a perfect circle or oval in order to achieve an acceptable freehand rendering.

Solving Graphical Problems

In most cases, landscapes resist falling completely within the principles of linear perspective. Apart from the incidental presence of some construction, the landscape is a disorganized whole with no foundation in geometry. Some subjects, however, can be rendered by applying simple techniques that do not require you to calculate points on the horizon or vanishing lines.

URBAN CLUSTERS

Urban landscapes provide the most opportunities for applying linear perspective. But when the view includes an entire town instead of a single building, street, or square, clusters of houses can appear chaotic, disorderly, and very difficult to arrange. A useful technique in these cases is drawing a "fenced-in" ground like pavement or cobblestones, based on two vanishing points in the horizon. You can then place different groups of houses on this grid; the houses grow smaller as they approach the horizon.

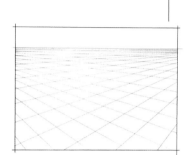

1. This grid was drawn based on two vanishing points located beyond the four corners of the page. The spaces between the "tiles" are imprecise because no measuring instrument was used.

2. Spaces in perspective serve as locations that contain different houses in isolation or in clusters; the only purpose of the spaces is to ensure a general, unified perspective in the placement of the houses.

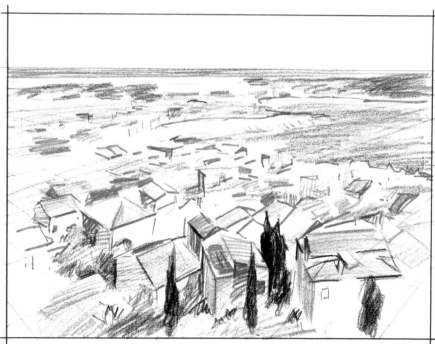

3. Finally, this drawing achieves a general view that reflects the complexity of a village. This aid in perspective isn't based on a rigorous plan, but it is useful nonetheless for orienting the drawing of scenes with an abundance of details.

DIAGONALS

The effect of perspective can easily be achieved when the landscape includes a clear diagonal that orders the elements of the drawing from foreground to background. The diagonal can be a coastline, a hill, a fence, or any other linear element that crosses the composition. In these cases it is not necessary to find additional perspectives, because the depth of the landscape is already clearly represented.

The foreground in this drawing creates a small diagonal that is defined enough to create an illusion of depth.

A diagonal orients the view from the foreground to the most distant points on the horizon. Perspective is achieved without resorting to any geometric processes.

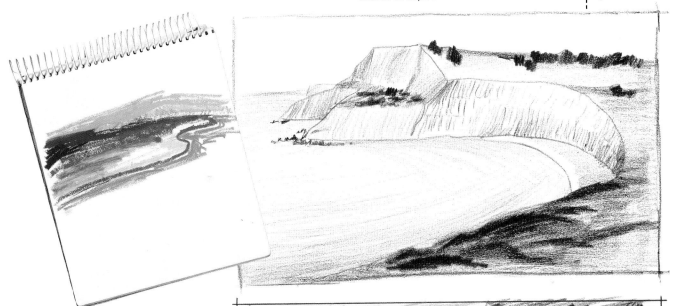

Distortion in the drawing is an extreme technique for creating perspective. This beach curls around to indicate the distance from the foreground to the horizon.

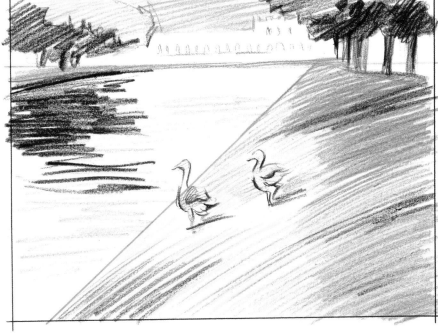

A diagonal across the composition can suffice to express the depth of the landscape. It can be a single vanishing line that coincides with the shore or a hill.

Aerial Perspective

Linear perspective is one of many means of representing depth. It is also the least natural and the most technical method in an artist's repertoire. Aerial perspective is much more sympathetic to the spirit of landscape. It is a means of expressing space based on the effect of the atmosphere on the appearance of the landscape. Aerial perspective is based not on the laws of geometry but on very simple visual concepts.

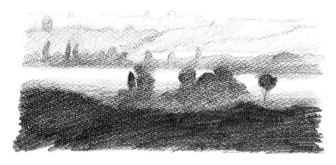

The different planes in a landscape grow paler as they approach the horizon. This is the principle behind aerial perspective; the atmosphere is an active, visible agent in the landscape.

The atmosphere not only softens the objects in the distant landscape—it also blends together the different planes between objects, revealing the distances that separate them.

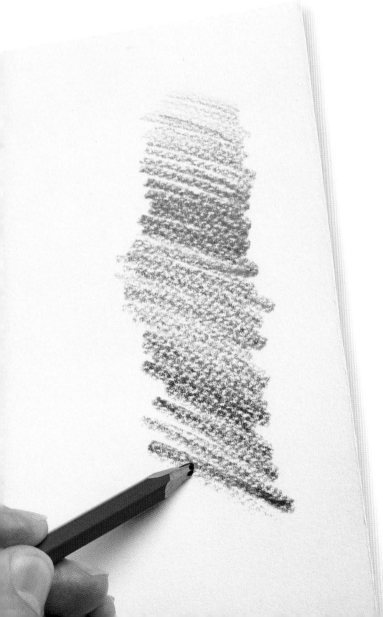

HIGH & LOW DEFINITION

Aerial perspective is the illusion of distance created by the blurred appearance of faraway objects in the landscape. The atmosphere in the space between us and the more distant objects in the landscape produces this effect most noticeably on foggy or cloudy days, and at dawn. When drawing expansive landscapes, take this effect into account and juxtapose the low definition objects in the distance with the high-definition objects in the foreground.

1

2

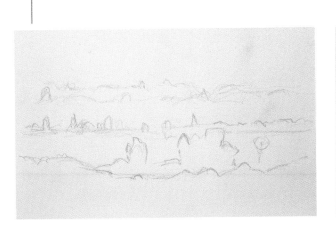

1. A drawing in aerial perspective begins with a very sketchy drawing that shows no clear delineations of its spaces.

2. Work gradually from soft to dark tones, leaving distant objects ambiguous, without emphasizing the contours and contrasts.

DIFFERENT CONTRASTS

If there is generally higher definition in the foreground, it is also here that the contrast is greatest. Light and dark tones, the contours of light and shadow, are more pure and contrasting in the foreground than in the distance. The depths of the landscape have a general overall tone, with little distinction among the edges, contours, or contrasts of light and shadow because the atmosphere envelops them in a unifying lens.

3

3. The planes of the landscape grow progressively darker and more heavily outlined as they get closer to the viewer.

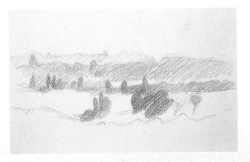

4. Atmospheric perspective creates a convincing illusion of depth using tonal gradation alone, without relying on a linear scaffold.

4

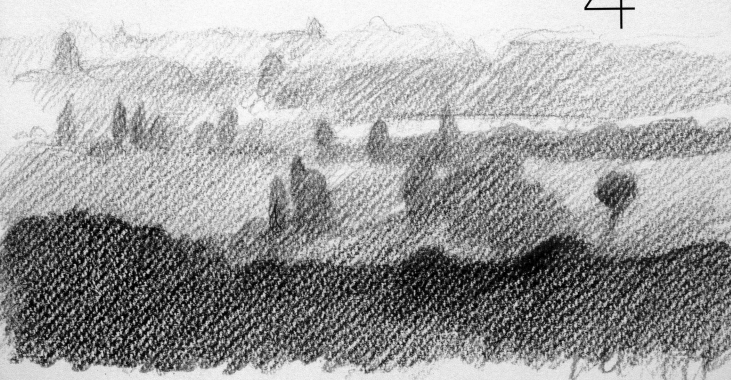

Atmosphere & Significant Contrasts

Atmospheric perspective depends on contrasts. By distributing these contrasts correctly, you can create the sensation that there is space in between the different regions of the drawing. But the atmosphere alone does not create these contrasts—light is also important. So a landscape in which atmospheric perspective is dominant will capture the qualities of both air and light to show depth.

THE INTERPLAY OF FULLNESS AND EMPTY SPACE

There is much more in any landscape than meets the eye—things we infer, things we deduce. The atmosphere obscures these details, allowing the viewer to see just enough to fill in the details that are not visible. The same thing happens when the artist purposely leaves empty spaces in a drawing. The empty spaces are part of the total effect of the drawing and produce the sensation that light and air have blurred the shapes underneath. It is a process of selection: objects in the foreground are energetically emphasized, those in the middle plane are merely suggested, and the background can be left blank.

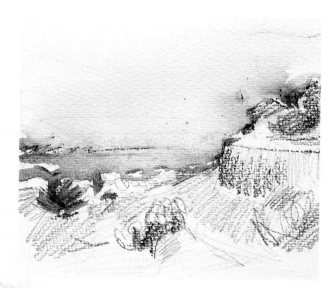

Clearly depicted objects and those that are merely suggested complement one another and enhance one another. In this lovely work, the details that are only hinted at, or omitted altogether, are as important as the shapes that are clearly depicted.

1. You can see from the very first stages of this drawing how darker strokes define objects that are closer to the viewer. The shapes of the trees are outlined by strokes that suggest branches and leaves rather than being defined by their contours.

2. Avoid blocks of shadow or very thick crosshatching—the objective here is to envelop every detail of the drawing in light and atmosphere.

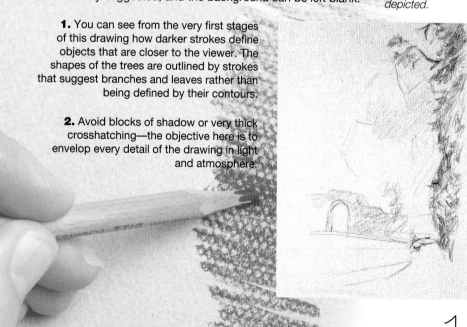

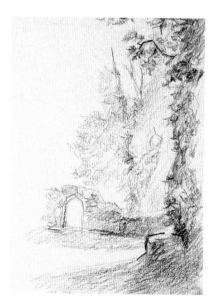

1

2

SHAPES & BACKGROUND

When drawing on colored paper, the effect of aerial perspective can be achieved by playing with the tones of the paper and the strokes of the drawing. In this drawing on gray paper in charcoal pencil and white chalk, the combination of blacks, whites, and grays against the color of the paper suggests details that have not actually been drawn. The shapes in front and the background work together to create a luminous, atmospheric effect.

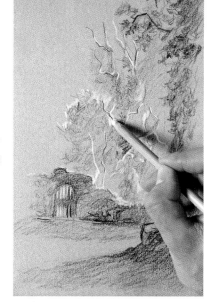

3. The whites add luminosity and complement the gray and black tones that dominate the scene. The strokes are not squeezed tightly together, and the gray of the paper is visible in every part of the drawing.

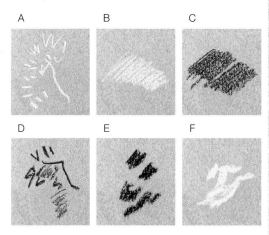

A. The highlights in the branches are simple strokes of white chalk.
B. Parallel marks in white render sunlight falling on the earth in the middle ground of the drawing.
C. A few soft parallel marks in charcoal pencil are enough to define the shadows in the foreground.
D. The branches are rendered in marks, not spots. The looseness of the marks gives the trees luminosity and lightness.
E. The densest black tones create small spots representing different parts of the branches in the foreground.
F. You can see some solid whites in the lighted parts of the wall in the middle ground of the painting.

4. The finished drawing reveals the space that separates the different objects and the way in which the light touches the objects in the distance.

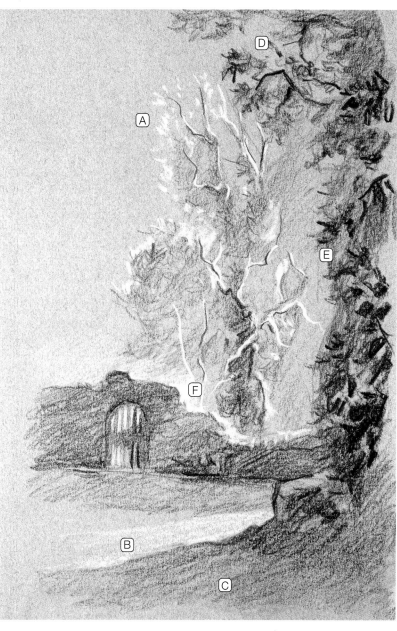

Atmospheric Gradations

The easiest and most direct way to represent distance when working in aerial perspective is by using tonal gradations in any of the usual methods—hatching, blending, strokes of different intensities. This is done by applying one of these techniques systematically from the top of the painting to the foreground, grading the contrast in tones so that they are strongest in the foreground and much softer in the distance. The result should be a continuous, softly nuanced fabric of strokes or spots.

ATMOSPHERE & GRADATION

The atmosphere is a unifying factor in any drawing: its representation gathers the different elements of a drawing so that they work together. The opposite of atmospheric representation is linear representation, in which each element has its own distinct contour independent of the rest. If you grade a tone into several different shades, the boundaries of the different objects in the drawing open up and mingle with neighboring tones. The differing intensities of the graded tone make the objects visible.

CONTINUITY & BREAKS IN GRADATION

A tonal gradation in pencil is a layering of strokes in one or several directions, creating smooth transitions between darker and lighter tones. This way of grading is well suited to "thick" atmospheres in which it is impossible to distinguish the outlines of each object clearly. In places it is possible to create a contrast that breaks with the continuity of the gradation and identifies the shape of an object.

When working in linear representation, grading a tone in different shades and intensities makes objects visible.

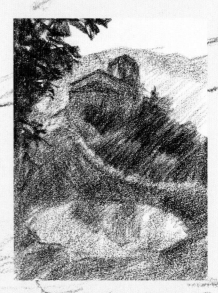

When the entire drawing is rendered in an atmospheric gradation, as in this careful drawing, the result is a powerful luminosity that affects every element of the landscape.

Atmospheric gradations consist of a continuous shading in which each element of the landscape is represented solely by a degree of light or dark in the fabric of lines and shadows. The resulting effect is atmospheric, with a luminous quality.

1. In order to evoke atmospheric density, avoid continuity in your lines: the preliminary sketch for the drawing should consist of a few spare details here and there, with no continuity between them.

2. The strokes are applied in a single direction, like a sheer curtain hinting at the landscape underneath. This atmospheric curtain obscures the outlines of the objects in the landscape. The volumes look like bulges or more intense strokes.

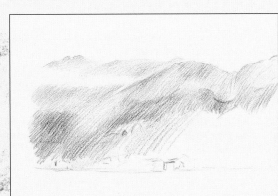

3. After drawing the entire atmospheric curtain, add some highlights and details to better express the distance between the nearby areas of the valley and the mountains in the distance.

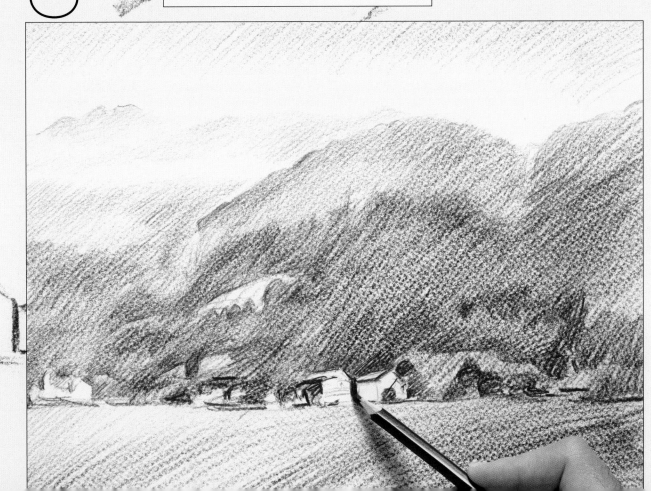

The Sky & the Atmosphere

The sky is an important factor in any atmospheric rendering of the landscape. Even in the absence of clouds or details, its tonality affects the entire work.

Clouded landscapes are sometimes more interesting at the top of the picture than at the bottom. Clouds can create their own varied and appealing scenes on different planes of the horizon.

The fog that covers the elements of a landscape also affects the appearance of the sky, making its tone smoother and lighter and blending it into the tones of the horizon. The transition of the objects in the distance into the tone of the sky should be very smooth and imperceptible. This factor is essential to achieving an atmospheric quality that will result in a convincing illusion of depth.

CLOUDS ON THE HORIZON

The sky tends to be more important in atmospheric landscapes than in landscapes with well-defined outlines. This is because there is no truly significant formal or tonal contrast between the sky and the different planes in the landscape—instead, they blend into one another. You can add subtlety to the great plane of the sky by adding a few smooth shadows to break up the uniformity of its tone.

A COVERED SKY

On cloudy or rainy days, the sky has a unique quality that makes it the central feature of the landscape. On these days the objects in the landscape appear in their simplest form; some of the planes disappear among the clouds, and shapes lose definition.

1

1. Landscapes with an enveloping atmosphere and a prominent sky begin with extremely simple compositional sketches. Keep your sketch flexible; avoid an overly rigid order that destroys the suggestiveness of the atmosphere.

2

2. When working on colored paper, you can draw sky using a direct tone, as in this drawing. The entire area of the clouds is covered in pure white to achieve a very cold, wintry tonal plane.

3. The details of the terrain in this drawing were created using two colored pencils, blue and sienna. Their pale tones, added to the gray of the paper and the white that dominates the scene, produce a sensitive composition wrapped in a cold, still atmosphere.

3

A. The soft whites of the snow on the ground are parallel strokes, applied with almost no pressure on the pastel bar.

A

B. The blue-and-white tones are placed on the edges between the snow and its bluish shadow. Layering colors adds nicely to the general atmosphere of the drawing.

B

C. The densest blacks represent the tree trunk. They were created using a charcoal pencil.

C

D. In some areas, the blue and sienna tones are applied like cornices that interrupt the monotonous continuity of the surfaces.

D

E. Blue streaks shade the foreground and reinforce the sense of coldness.

E

F. The gray paper is just visible under the pastel white sky. The atmosphere is cold.

F

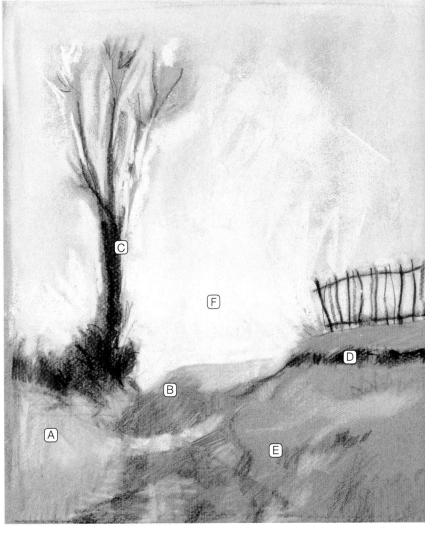

Graphic Styles

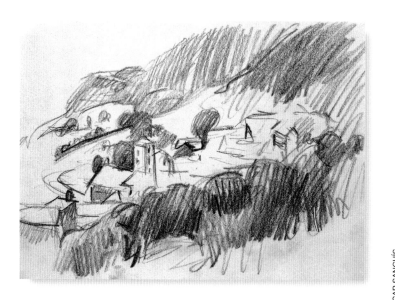

ÓSCAR SANCHÍS.
SKETCH OF A MOUNTAIN VILLAGE, 2003.
GRAPHITE PENCIL.

in Landscape Drawings

Having a clear grasp of the principles

of drawing and their application ensures that your landscapes will be technically accurate. But the way in which you translate these notions onto the paper can be of even greater importance than mere theoretical knowledge. A graphic style is the way in which drawing instruments are used to render a visual idea. An effective graphic style means being sensitive to the possibilities of each medium in order to get the most out of it and achieve the best visual results.

Sketching with Charcoal, Graphite, Pastels & Chalk

When does a drawing cease to be a study and become a true work? This is a difficult question to answer today, when most landscape artists enjoy an uninhibited, freehand style, the legacy of the Impressionists' relaxed manner. The sketch or on-the-fly study made on an outing in the country sometimes contains an expressiveness that gets lost during the patient elaboration of a more labored work. Simple graphic media are the best vehicles for this kind of expressiveness.

GRAPHITE PENCIL & CHARCOAL

These are the most immediate and agile of traditional drawing media for making studies and quick sketches. The slightly metallic stroke of the pencil, which is much denser in soft lead, produces the best results when used for quick sketches based on tentative strokes, but this doesn't rule out including well-defined details with a sharp point. Charcoal doesn't allow for many details, but the incomparable warmth of its strokes makes it a most appealing graphic medium.

Graphite sticks are especially well suited for studies and quick sketches: although they are as thick as ordinary pencils, they are not encased in wood, and so they produce very different lines and strokes.

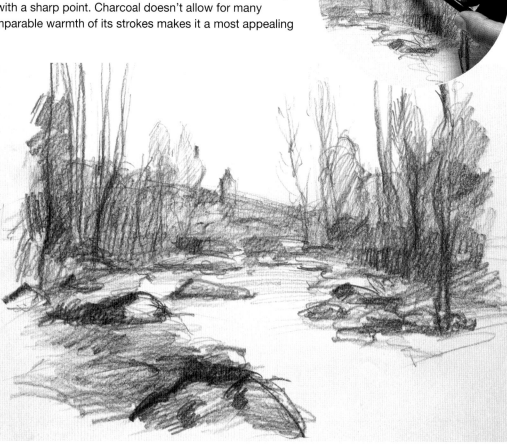

Graphite pencils, especially soft ones, make sketching and studies easy by allowing you to combine different outlines, hatchings, and strokes. They can be used on white or lightly colored paper.

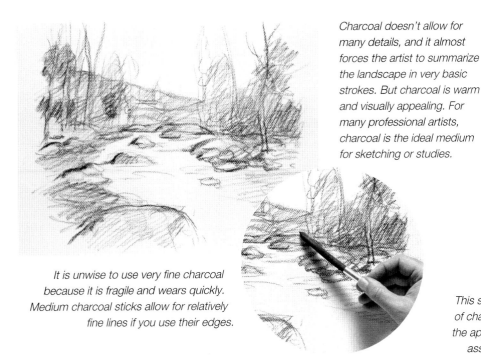

Charcoal doesn't allow for many details, and it almost forces the artist to summarize the landscape in very basic strokes. But charcoal is warm and visually appealing. For many professional artists, charcoal is the ideal medium for sketching or studies.

Hard pastels in reddish tones, such as red ochre, brown, or sepia, produce energetic but also subtle results. Their strokes are intense, but they can be blended or faded, and, when applied to a slightly grainy surface, they allow you to polish the details of the drawing.

It is unwise to use very fine charcoal because it is fragile and wears quickly. Medium charcoal sticks allow for relatively fine lines if you use their edges.

This sketch on colored paper uses three colors of chalk: sepia, white, and ochre. If you choose the appropriate surface, chalk and pastel colors assume a graphic and chromatic quality that turns the simplest of sketches into a striking work in its own right.

CHALK & PASTELS

In general, chalk and pastels resemble charcoal in the width of their strokes, but otherwise they allow for much richer chromatic work. Their coverage is strong enough that you can use them on colored paper—in fact, colored paper is ideal for these media. A selection of three sharply contrasting colors (a dark color, such as sepia; a medium tone, such as ochre; and white) can produce sketches or studies that are visually very appealing.

Chalk produces very strong effects in just a few applications, especially on surfaces whose color simultaneously contrasts and harmonizes with the chalk.

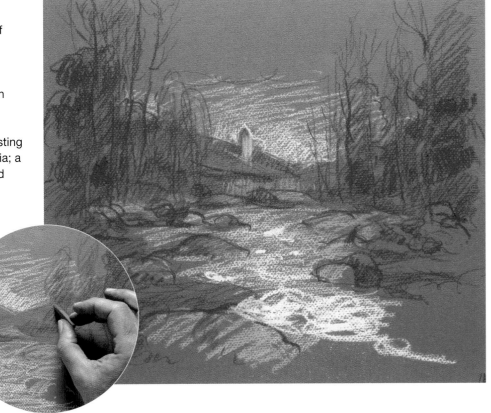

Ink-Based Media

The ballpoint pen is a comfortable, quick-to-use instrument. It can be used effectively on almost any paper surface and produces interesting, if somewhat cold, results.

Like the ballpoint pen, markers are a very comfortable medium. Their line doesn't vary, but you can produce a more tenuous line by using dry, older markers.

Any ink-based drawing instrument is ideal for sketching. Pen, brush, and reed are characterized by quickness and agility. Mistakes in ink cannot be corrected, so they force you to make quick, final decisions: if you make a significant mistake, you take out a fresh piece of paper and start all over. When you work this way, the end results have a surprising freshness and immediacy, whether you have used a fountain pen, reed, marker, or ballpoint.

MARKERS & BALLPOINT PENS

Fine ballpoint pens produce a very fluid, continuous line. Although they lack the personality of a steel-tip pen, they give the obvious advantage of not needing to be refilled constantly. The fundamental merit of these instruments is their ease of use. Markers can be thought of as a modern-day version of the reed, and the advantages of the ballpoint pen also apply to them. Some artists use old, dry markers to achieve the characteristic irregularity of the reed.

FOUNTAIN PENS & REEDS

The fine lines of a fountain pen can suggest the most intricate thickets, the most complex textures. The reed is a much more versatile instrument than its rough appearance would suggest. It allows you to make fine, precise lines as well as thick and solid or faded strokes, depending on the amount of ink on the tip of the reed. It allows for greater graphic energy in a sketch because its strokes are thicker, making fine detail very difficult.

1. You can see the characteristic line of a reed in the basic lines of this landscape. The reed's lines are discontinuous and vary in width, and it is very lively and responds sensitively to subtle motions of the drawing hand, imprinting quick motions on the paper immediately.

2. Dark masses can be rendered by layering lines of varying density and direction. This creates an interesting texture that covers everything and creates a stark contrast between the white of the paper and the black ink.

A. Thick, heavy lines are obtained by placing the beveled edge of the reed pen flat against the paper.

B. Turning the reed pen upside down and drawing on its edge will produce fine, thin lines.

C. These lines were made by unloading some of the ink on a separate piece of paper.

D. Moving the reed pen slowly over the paper allows the ink to accumulate, thus creating ink stains.

E. Shading with the reed pen is accomplished by crisscrossing various lines with different intensities.

F. The details in a reed pen drawing should be simple, and reduced to the most elementary lines possible.

A B C D E F

3. The varying width of the reed's lines depends on the position of the tip on the paper. To create strokes of lighter intensity, first use the reed on a piece of scrap paper until there is almost no ink left on its tip, then use it to create delicate, faded lines.

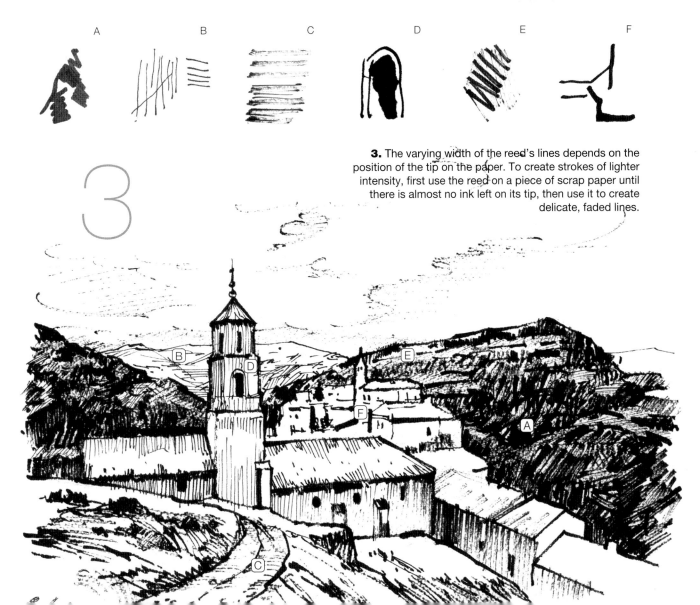

Brushes are good partners for any ink-based drawing media. You can use the brush directly, dipping it in ink and spreading it across the page, or for fading, by diluting and spreading earlier lines in ink. When working with brushes, keep a container of water handy to reduce and soften the color and to clean the brushes themselves.

Using Brushes to Make Color Sketches

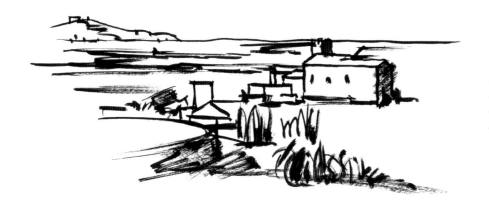

This landscape was drawn with brushes. The variations in the width of the brushstrokes were produced by applying more or less pressure on the brush, so that different amounts of ink were released onto the page.

Some examples of the different strokes you can produce using brushes and India ink: from the finest lines to the thickest comma-shaped strokes, plus attenuated strokes made with a nearly dry brush.

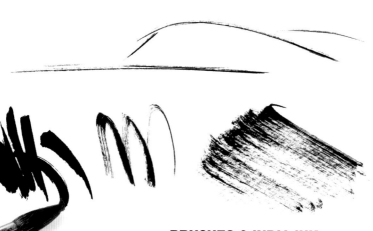

BRUSHES & INDIA INK

The graphic force of India ink makes it very suitable for works in brush. Its solid black tone doesn't fade when you spread it in wide swaths, unless you dilute it with water. For this reason, silhouettes and spots are the dominant elements in studies in brush and India ink. As with a reed, you can lightly discharge the ink on a piece of scrap paper to produce more translucent strokes that reveal the texture of the paper in your drawing.

BRUSHES & COLORED INK

Unlike India ink, the tone of colored ink
fades when you spread it with your brush.
These are transparent inks that resemble
watercolors. The basic inconvenience of using
them is that they are impermanent and discolor with
prolonged exposure to light, but this doesn't mean they
can't be used for sketching, or even for a preliminary study of
the tones in a landscape. The inks dissolve easily in water
and allow for a broad range of tones, from saturated colors
to very subtle washes.

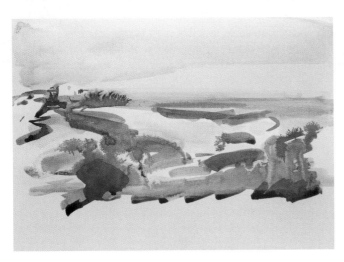

*Colored inks don't mix
well (watercolors do),
so it is best to use just
a few tones. Each color
is applied by dipping the
brush directly into the
palette.*

*When applied with a brush,
India ink allows you to
make strokes of many
different widths, from very
fine lines to solid black
swaths. It is essential that
you control the pressure
and motion of the brush on
the page.*

*A sketch in blue ink and brush. This technique
is practically identical to watercolor: The shapes
are described by their mass and by a white
silhouette surrounded by blocks of color.*

*This could well be a spot of
watercolor, though it is in fact blue ink.
Unlike India ink, colored inks fade as
you spread them on the paper.*

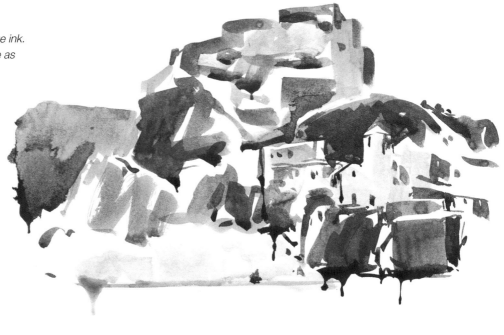

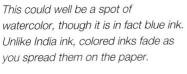

Sketching & Mixed Media

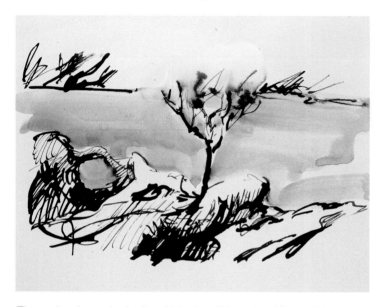

The reed and a wash of colored ink mix well in works with a decisive, energetic style. The strokes of the reed in this drawing are applied with total freedom in order to suggest the random shape of the coastal rocks.

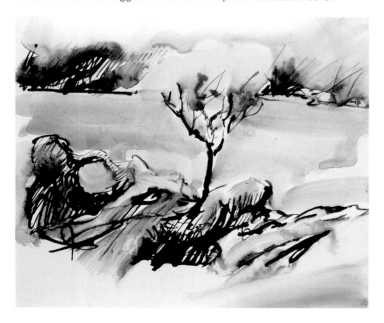

The only technical limits in sketching the landscape are the experience and imagination of the artist. All of the techniques we have seen so far can be combined in one way or another within the same work. But this can prove messy sometimes, and on occasion the desired result is achieved only after many attempts. Ink-based methods can be combined in many different mixed media; doing so depends only on your willingness to carry them with you when you go out into the field to draw.

REEDS & BRUSHES

Combining drawings in reed with brushstrokes is a good idea when you seek an energetic, somewhat baroque result. Rocks or seashores, characterized by motion and fluidity, lend themselves to an equally energetic interpretation. There is no specific order in which the different techniques must be applied, but the logical place to start is the reed because it is primarily a drawing instrument. When working in this way, remember that spots of ink dissolve when you pass over them with a wet brush; it is important to be aware of this fact so that the final drawing doesn't look dirty or smudged.

When applying washes of color (colored ink, in this case), keep in mind that India ink dissolves partially when it comes into contact with water, and an application of color with a wet brush can fade some of the earlier reed strokes.

REEDS & MARKERS

Some pages ago, we remarked on the similarities between reeds and markers; their differences, however, are far more pronounced. While reeds allow for an enormous variety of applications, markers produce strokes of an even, unalterable intensity and width. Markers can be used together with reeds to render areas and details that require a surer or more systematic treatment. Because the reed is stronger graphically, it is better to use it for the more appropriate aspects of the subject or to highlight its general structure.

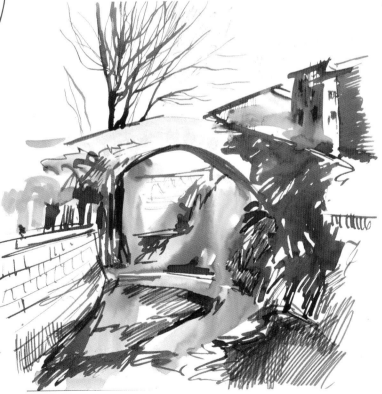

1. In this sketch in reed, the first step is to add a few brushstrokes in dark red ink to mark the general dimensions of the drawing. The strokes of the reed, with their more saturated color, create large areas of light and shadow through a layering of loose, spontaneous strokes.

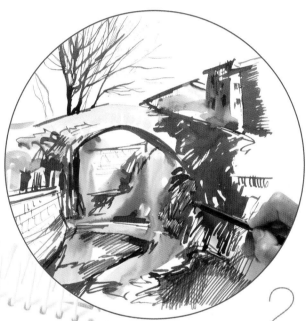

2. The marker, which is much weaker graphically, is used here to detail some of the areas in the drawing that have not been treated in reed. Any areas you fill in marker will necessarily be a sort of hatching.

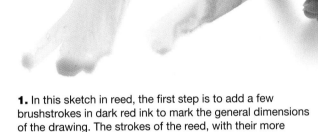

3. Combining reed with markers results in a luminous and graphically powerful drawing. This is also true of any mixture of black or color ink-based drawing techniques.

Linear Perspective

Linear perspective is a system for representing depth based on simple geometric principles. In a landscape, this perspective tends to go unnoticed, because straight lines do not occur in nature, nor do parallel lines. Perspective becomes indispensable when you are drawing buildings or towns, or any urban subjects. The basic concepts of perspective are easy to understand and apply, and are very useful for solving problems in space and distance.

THE HORIZON LINE

The horizon is always before us, straight ahead at eye level. The clearest example is when we look at the ocean: The horizon line will be at eye level, whether we are on the beach or atop a building. Thus, the height or elevation of the horizon in a landscape depends on the point of view from which you choose to draw it. When it is not immediately visible, the horizon can be deduced from the vanishing lines of the subject. This means that all the vanishing lines lead to a given point on the horizon—the vanishing point.

Linear perspective creates a powerful illusion of depth in urban landscapes, in which rectilinear organization is dominant.

A B

The horizon is always at eye level, no matter where we are. This correspondence between point of view and the level of the horizon is a basic principle of linear perspective (A). When we raise our point of view, the horizon line also rises. This is the basic reference in the representation of perspective (B).

POINT OF VIEW & THE VANISHING POINT

The point of view is always somewhere on the horizon and is equivalent to the vanishing point, which is the place where all the vanishing lines lead in the drawing. This is because the eye is the place where, logically, all possible images converge. When you are drawing a landscape, this point of view is defined by a point on the horizon: the vanishing point. It follows from this equivalence between the point of view and the vanishing point that the convergence of images in the eye is translated in our representations by the convergence of the vanishing lines.

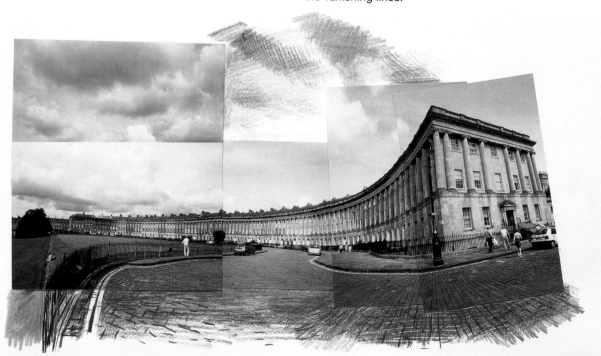

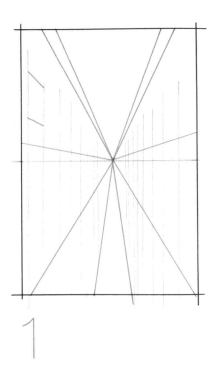 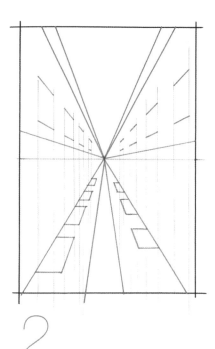

1 2 3

1. Any construction in perspective requires a horizon and, at the very least, one vanishing point. Here we have both. A series of lines, extensions of simple architectural elements, lead to the vanishing point.

2. The windows and doors are also aligned with the vanishing point in this idealized scene.

3. After finishing a few details, we have assembled a simplified view of a street. As in all visions in perspective with a single vanishing point, the point of view and the vanishing point are one and the same.

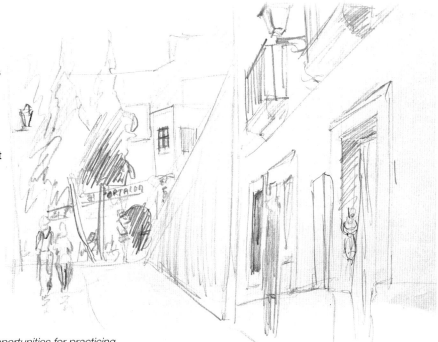

Cityscapes offer constant opportunities for practicing perspective. Naturally, this quick sketch requires no geometric elaboration and can be finished intuitively.

Using Contrast to Organize Space

Shadow areas can be organized so that the contrasts that they create on the page can be interpreted as special relationships, as being far or near in the space of the composition. When the areas that define shapes are partially covered, they act as screens that obscure what lies behind them. The interplay between these "screens" encourages a progression into the depth of the drawing. This is based on the principle of simultaneous contrast: a light screen is superimposed on a dark one, and vice versa.

SCREENS IN THE LANDSCAPE

The masses of trees, rocks, hills, the edges of the terrain, and, in general, all of the elements that cover part of what lies behind them, can become screens with which you can express a progression into the depth of the landscape. These screens are somewhat like the framing on a theater stage, like a natural decoration that defines the spaces in the landscape. In order for this succession not to appear artificial, it is necessary to use the principle of simultaneous contrast.

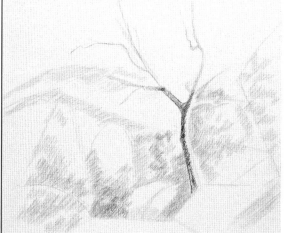

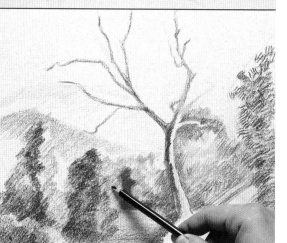

1. The rendering of a landscape organized by screens requires a firm preliminary sketch in which the entire space is organized by simple compositional lines.

2. Tones are softly distributed, with an effort made to establish the size and location of every screen in the drawing. Begin shading progressively, especially on the lower parts of bushes and trees.

3. Each mass of trees creates a screen with the mass behind it, so that the most lighted area coincides with and is defined by a shaded area, creating simultaneous contrast.

4. This is the finished drawing. Every screen or border is perfectly visible. Note how they are superimposed on one another by alternating lighted and dark areas, organizing the landscape and suggesting distance.

A. Crosshatches in charcoal pencil create soft shading on the mountain crests that enclose the composition in the background.
B. The darkest shadows are created using dense charcoal pencil marks, with no trace of individual strokes.

C. The more lighted areas are layers of white chalk pencil.
D. The softer shadings are parallel hatches in charcoal pencil that separate to suggest a gradual lightening.
E. The relief of the branches is made by opposing a stroke of charcoal pencil and a stroke of white chalk.
F. Some of the intermediate tones have been rendered by superimposing charcoal and white chalk marks.
G. The most energetic shadows in the foreground are made of spiraling layers of charcoal.

INTENSITY OF CONTRAST

The greater the contrast between one screen and another, the greater the illusion of space between them: the greater the contrast, the longer the distance. This general principle applies to any sketch or quick drawing. It is enough to juxtapose a light element and a dark one in order for the dark one, if it is roughly the same size, to appear closer to the viewer. Not only does the space appear more realistic, but the drawing, too, becomes more graceful and vital.

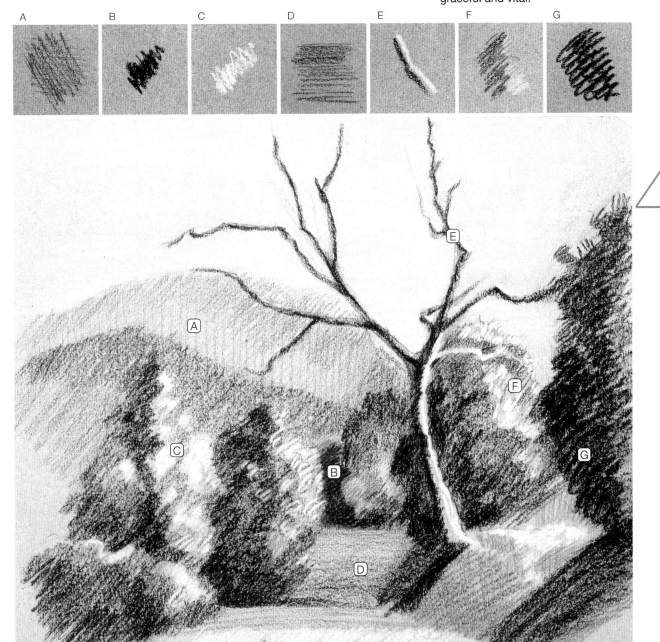

Simultaneous Contrast

The modeling of shapes can be done individually, by emphasizing the most important textures in the subject, or systematically, by pushing an object to the foreground through the use of contrasts. Simultaneous contrast is a modeling technique that consists of foregrounding textures through a continuous contrast of dark on light and light on dark, ensuring the unity of the drawing. It is based on the idea that a color or tone will look lighter against a dark background and darker against a light background.

LIGHT ON DARK, DARK ON LIGHT

To bring out the volumes in a drawing, it isn't necessary to darken their shapes. You can simply darken the background behind them. This makes the lighter object more prominent without using harsh, disruptive outlines. Where a shape blends into the background, it is enough to darken that background so that the outline of the object becomes visible.

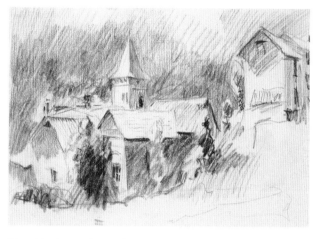

The shingles on the rooftops appear much lighter than the white of the paper as you apply gray shading to the paper. This gray background can represent the sky or a mountain, but it is unnecessary to justify it except to say that it creates an effect of luminosity.

1. Simple shapes best illustrate the logic of simultaneous contrast. These blocks are an outline of a megalith (like Stonehenge), which serves as an opportunity to practice this drawing technique.

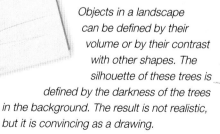

Objects in a landscape can be defined by their volume or by their contrast with other shapes. The silhouette of these trees is defined by the darkness of the trees in the background. The result is not realistic, but it is convincing as a drawing.

UNITY OF LIGHTING

When creating simultaneous contrast, the artist constructs a landscape according to the shape, size, and arrangement of the objects within it. The background is therefore not a single tone; it varies depending on the depth of the different elements—lighter against shaded volumes, darker next to the more lighted parts of those volumes.

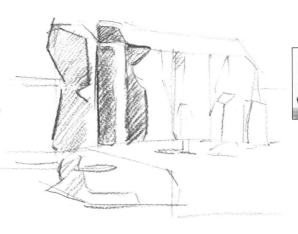

Simultaneous contrast is a function of the fact that shadows not only model a concrete shape but also help to model the shape next to it, making that shape's edges visible even without the help of a descriptive line.

2. The shadows of some of these stones define the lighting of the others. The lighted edges need not be drawn very elaborately, because their boundaries are defined by their contrast with the background.

3. Simultaneous contrast is based on the systematic juxtaposition of light and dark areas. Each lighted shape has a corresponding dark background, and vice versa.

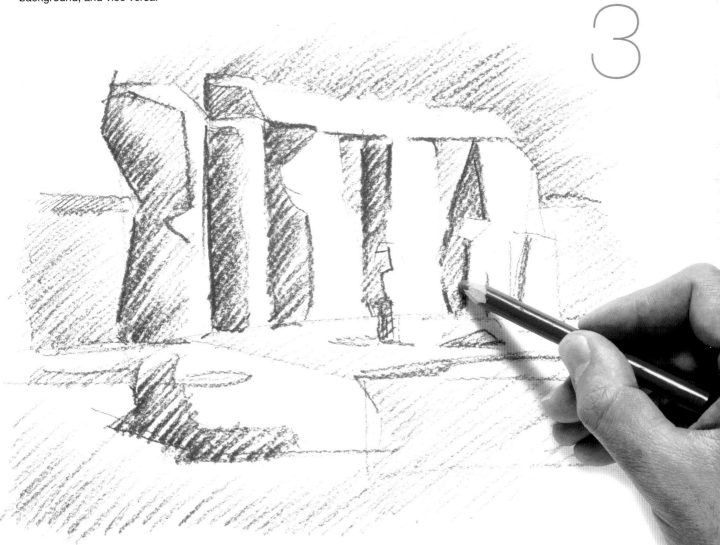

Shapes in Negative, Shapes in Positive

1

2

Simultaneous contrast allows you to define the depth and volume of your subjects in a natural manner, without forcing you to lighten certain parts of the drawing in order to emphasize others. Every element of the work is treated in a similar fashion, because every shading affects the neighboring shapes and no one detail is isolated from the rest. The drawing proceeds in an organic manner, and none of its parts assumes a predominant role at the expense of the rest. Light areas define darker ones and vice versa: the landscape is constructed as a "negative" and a "positive" simultaneously.

HOLLOW VOLUMES & FULL VOLUMES

When the landscape is drawn while searching for contrasts among tones, its shapes and contours are defined by these contrasts and not by line. The boundaries of a dark shadow inevitably suggest the contour of another shape, which need not be drawn. When this occurs, avoid emphasizing the edges of the shape with a very pronounced line—this looks redundant. By being aware that a shadow immediately creates a lighted area, you can avoid shading so that the adjacent shapes appear in negative—without your actually having to draw them.

CONTRAST, RELIEF & VOLUME

The interplay between positive and negative shapes is well known among landscape artists, including both those who work exclusively in tonal drawings and those who work in color. Respecting the blank spaces on the page by "drawing" their exterior is not only a very useful technique, but also an elegant way to represent the properties of any subject with a light, confident touch.

1. When applying the principles of simultaneous contrast, it isn't necessary to labor over the line drawing. An overworked drawing will make the construction of positive and negative shapes rather awkward.

2. As you can see, the light parts are not drawn in at all; they are defined by the darkness that surrounds them. These shapes in negative, in turn, define the shapes in positive, the shaded volumes.

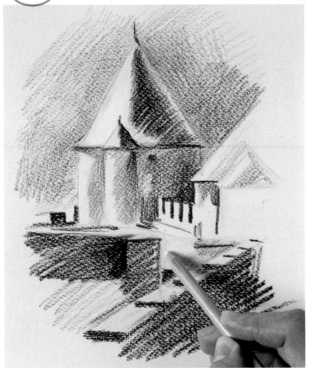

3. On colored paper, you can add nuance to the blank areas by using white highlights to accentuate the volume further.

Even when it is not applied systematically, simultaneous contrast is an almost inescapable technique when the artist is trying to add nuance to the lighting on the textures of the landscape. Here, the blank areas are as important as those that are drawn in.

The most logical, sure-fire way to shade a drawing based on simultaneous contrast is by using graying effects with parallel or crossed hatching. This way, you can put together the drawing on the basis of shadows that contrast with the white spaces on the paper.

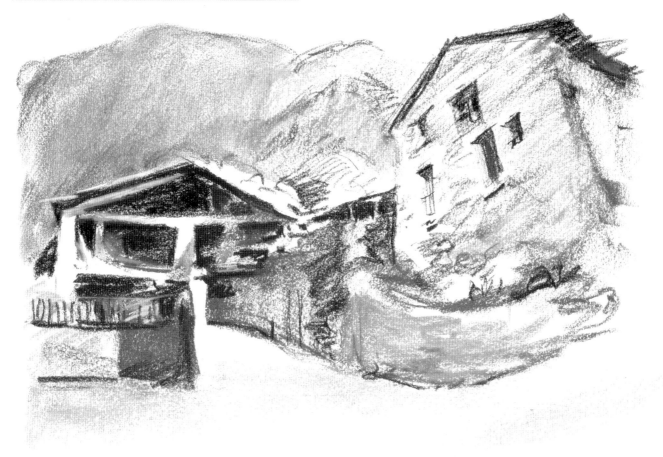

Shading with Strokes

When using instruments such as a graphite pencil, colored pencils, or any other instrument that produces very fine marks, the most logical technique is to shade by making the strokes more or less dense. In this intuitive shading, darker tonal values are achieved by intensifying the marks. The result tends to be brighter and more luminous than with stumping or blending.

THE PROCESS OF HATCHING

Hatching is the process of shading with strokes. You can begin with a simple line drawing, if the subject doesn't present significant composition problems, or by using a compositional outline in light pencil lines. From this point on, the process of hatching consists of layering strokes on the more shaded areas, intensifying them as the drawing progresses until you arrive at a final equilibrium between light and shadow. To reinforce the shadows, combine white or darker pencils (either colored or charcoal pencils). It is also possible to use a white chalk pencil, for example, to blend strokes and lighten areas.

VARIETY IN HATCHING

The strokes that define a drawing can be applied in several different ways. The marks can be curved or straight, vertical, diagonal, or horizontal. Short marks give nuance to the light and the shadows with greater precision; shading with short strokes also allows you to shape the foliage and the more irregular shapes in the landscape easily.

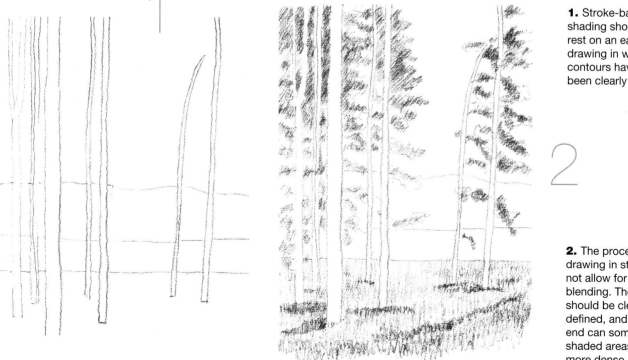

1. Stroke-based shading should always rest on an earlier drawing in which the contours have already been clearly defined.

2. The process of drawing in strokes does not allow for spotting or blending. The strokes should be clearly defined, and only at the end can some of the shaded areas be made more dense.

A

B

C

D

E

F

G

H

3. This drawing was made with red ochre pastel, charcoal, and white chalk pencils. All of its elements have been rendered using strokes. The denser areas show layers of red ochre pastel and charcoal, while the brighter areas are softly darkened using one of the drawing instruments.

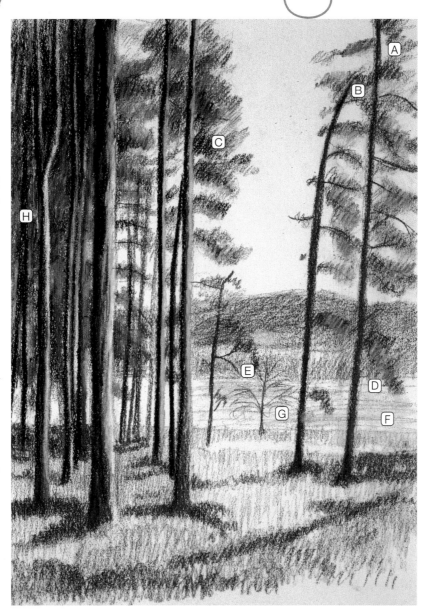

A. Red ochre pastel strokes give shape and, at the same time, shade in the foliage of the trees.
B. Softly detailed in black, the red ochre pastel strokes acquire depth and intensity.
C. In the more darkly shaded areas, the black charcoal marks end up almost covering the red ochre pastel.
D. Notice how the marks have been softened to avoid excessive contrast between the charcoal and the red ochre pastel.
E. The soft tonal values of the riverbank were made with perpendicular strokes of the red ochre pastel.
F. The water is suggested by soft horizontal lines in charcoal pencil.
G. Some details are not shaded or modeled but drawn summarily using charcoal pencil lines.
H. The more energetic molding of the tree trunks is dominated by thick charcoal strokes.

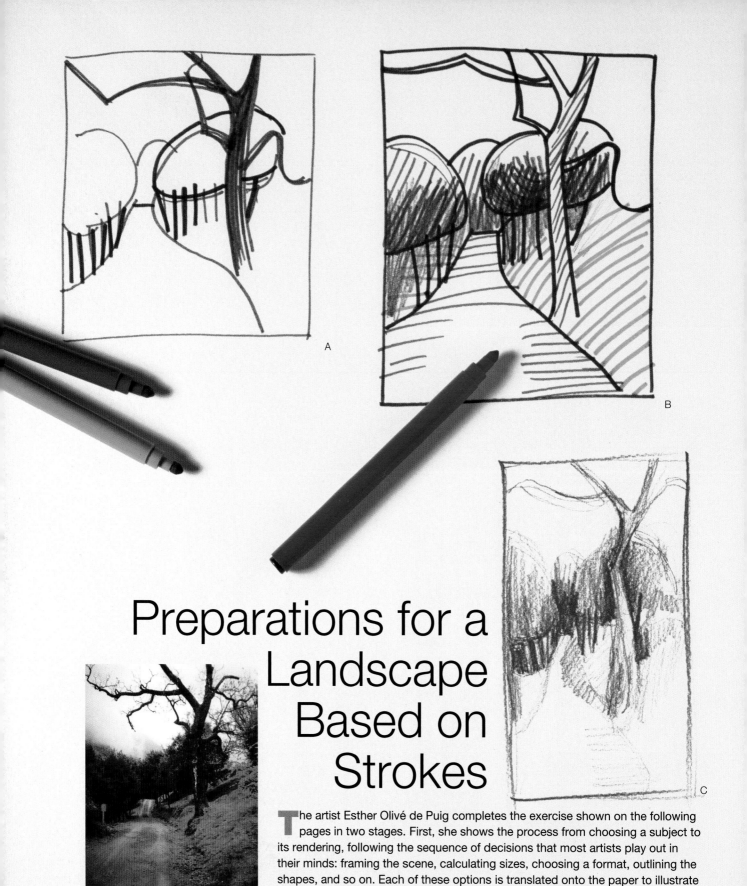

A

B

C

Preparations for a Landscape Based on Strokes

The artist Esther Olivé de Puig completes the exercise shown on the following pages in two stages. First, she shows the process from choosing a subject to its rendering, following the sequence of decisions that most artists play out in their minds: framing the scene, calculating sizes, choosing a format, outlining the shapes, and so on. Each of these options is translated onto the paper to illustrate the internal process of the gestation of a landscape drawing.

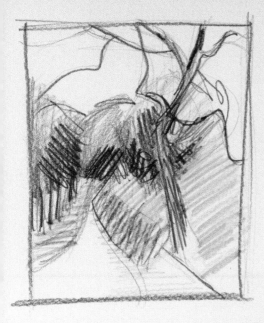

D

A. This drawing reflects the basic idea of the landscape, its basic composition. The center of attention is shifted slightly to the right of the center of the page. The branches form a hatching that weaves together the different elements of the drawing, and the lines of the path suggest an impression of perspective.

B. In this new drawing, the format has changed—it is now more vertical. Here, the branches should not be extended too far toward the left of the composition. The lines in marker distinguish the basic areas of the composition and shade the treetops in the background to check the graphical effect.

E

F

C. In this new study, the format is even more vertical, and this affects every factor in the composition: there is much more space in the foreground, the path is extended and appears narrower, and the trees grow closer together in the background.

D. Here the drawing returns to its starting point after the artist decides that the subject is not well suited to an extremely vertical format. This time, the artist opts for making the path narrower, in order to allow for more play toward the sides of the composition. The first indications of color are a tentative attempt at establishing chromatic harmony.

E. There is always room for fantasy in some significant elements of the drawing: the twisted branches suggest the stems and leaves that, in other seasons, decorate the empty space of the sky.

F. Try different drawing instruments during these early studies. The nature of each instrument yields new suggestions in the composition, line, and color of the drawing.

G. This final study summarizes all of the decisions taken over the course of this process. The format has been fixed in a rather wide vertical proportion, the branches form an appealing linear ornamentation against the sky, and the dense mass of the trees in the background is now defined with greater clarity.

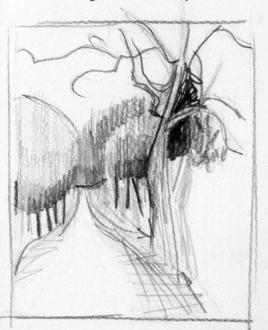

G

The artist used markers early in the sketching process, then switched to colored pencils. Markers are useful for outlining and sketching, but they can be too much of a commitment in a long and elaborate exploration.

A Landscape in Colored Pencil

After the exhaustive approach to choosing a subject shown in the previous pages, it is hardly necessary to justify any of the operations we now see the artist carry out in the process of framing and composing the landscape. Now Esther Olivé de Puig is creating the drawing itself. This process is based on graphite pencil work during the early stages, and colored pencils in the final rendering.

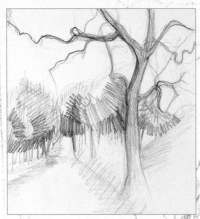

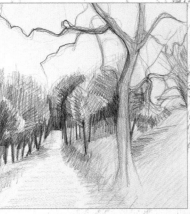

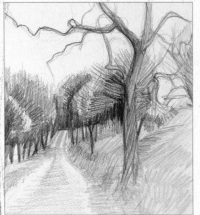

2

3

1

4

1. The initial outline is made while looking at the subject, while keeping in mind what has already been done in earlier studies. As you can see here, the initial sketch follows the earlier decisions point by point, which goes to show that, in drawing, seeing your subject in nature is almost as valuable as your imagination.

2. After a few approximations and tentative steps, the contours of the composition are firmly established. The parallel lines of the graphite pencil begin to construct the shading of the trees in the background. In this shading, the intensity of the tonal values are as important as the ornaments created by the pencil strokes.

3. The presence of color is still quite timid here. The gray tones of the graphite are dominant, but we also see some greens and reds that complement the shadings of the landscape.

4. You can now see clearly how the areas that define the tops of the trees account for their shadows and characteristic texture.

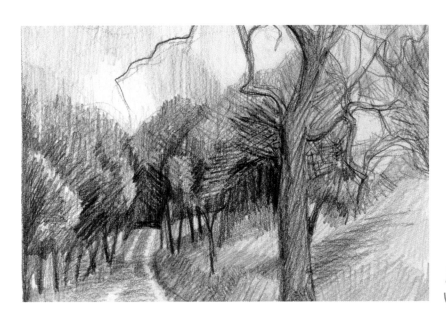

A basic, preliminary sketch that is well proportioned is the best guarantee for a problem-free drawing. The beginning steps are the most important.

5. Successive layers of colored pencil have created textures throughout the surface of the drawing—in the trunk of the tree in the foreground, for example, or in the green of the weeds that cover the sides of the path. Similarly, the progressive diminution of the parallel strokes that cover the path create a convincing sense of perspective.

6. The drawing has arrived at a high degree of elaboration, thanks to the early preparations for the work. Notice that the tones of the graphite and the colored pencils are perfectly integrated into a harmonious whole. The darker tones were created with graphite pencil; the intermediate tones are in colored pencil; and the lightest tonal values are represented by the white of the blank paper.

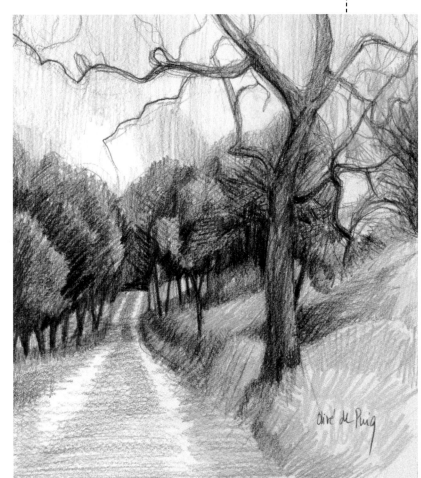

The difficulty of seascape drawings lies in rendering the ripples in the water. This difficulty can only be overcome by focusing on the problem correctly. The following pages show David Sanmiguel's preparations for drawing a seascape.

Preparations for Drawing a Seascape

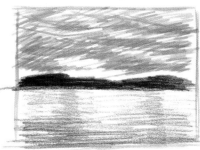

This is the first approach to the subject, using a marker. This sketch simply blocks in the subject, placing the horizon low on the page, and attempts a primary, general shading that affects the lower part of the sea and sky.

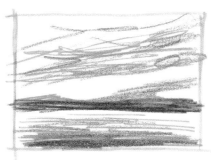

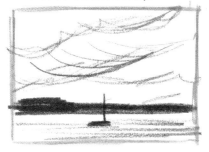

This second sketch does not go much further than the first. The horizon line is now even lower on the page, leaving little space in which to draw the waves. This option should be discarded.

The need to leave enough space to represent the waves forces you to lay out a composition with its horizon in the center of the frame but somewhat beneath the exact midpoint. Once you arrive at this point, you realize that the problem with representing the surface of the water has to do with the use of light and shadows rather than imitating each of the waves.

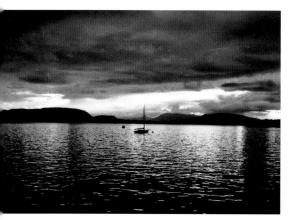

This sketch is merely a study for the graphic representation of the clouds and waves. It contains two different colors, which gives the appearance of dividing the drawing in two. You can see the waves rendered in the form of shaded crests that follow one another toward the horizon.

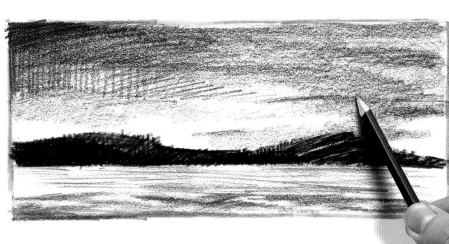

Try using cuttings of colored paper to study different approaches to rendering a drawing. These simple collages clarify the basic ideas—light, shadow, composition, and, lastly, color.

A preparatory "general study" made with paper cuttings. This is done to show the basic distribution of light and shadow on which the final result will depend. In order to achieve a convincing foreground, the greatest contrast between light and dark tones should appear in the waves closest to the viewer. The dramatic effect of the clouded sky is achieved by forcing the chiaroscuro contrast toward the horizon.

This study was made with the defining color: blue pencil. Notice how the waves are created by successive applications of shadows in long crest shapes that overlap with one another more and more intricately as they approach the horizon.

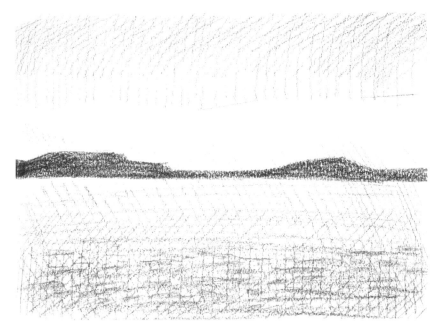

This is the general shading that will be used in the final work. The shadows grow denser toward the top and bottom of the composition, and remain lighter in the center of the page.

A Seascape in Blue Pencil

The preceding studies have allowed us to clarify a few ideas. The most important thing to remember is that the correct way of representing the surface of the water is to look at the problem in terms of light and shadows and not in terms of a concrete shape. Distributing the light and dark tones immediately suggests the ripples on the water. Beyond this, all of the decisions made in this drawing with respect to composition and general technique are based on the studies.

1

1. The initial compositional scheme is identical to the one reproduced in the preceding pages. The horizon line in the center of the page leaves enough room to develop the interplay of light and shadow in the lower part of the drawing. A few diagonal lines indicate the basic direction of the clouds and how they tilt toward the horizon.

2. First of all, the sky is softly shaded, a little darker toward the top, leaving white areas that suggest clouds lighted from below. A dark silhouette represents the mountains on the horizon. The waves are represented from the bottom up, with an emphasis on the shadows, by creating a succession of elongated spots in the shape of dunes or footprints, separated by white areas.

2

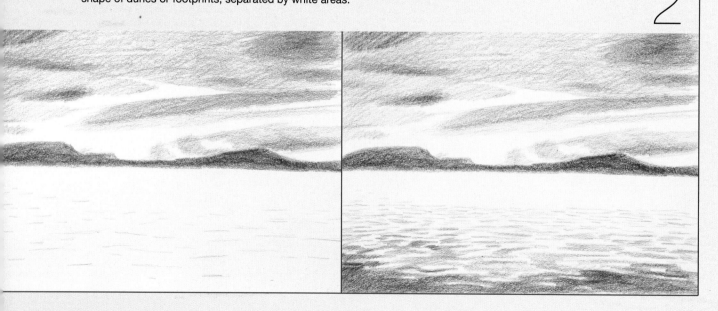

3. Here there is an emphasis on the shadows created earlier. Darkening the shadows on the waves heavily makes the white areas look like illuminated crests, creating an effect of motion. From this point on, it is simply a matter of repeating this effect toward the horizon, making the marks smaller and smaller each time and their tonalities lighter and lighter.

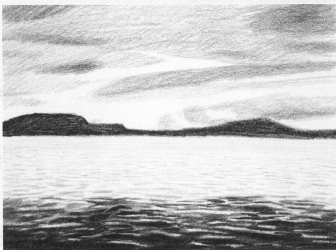

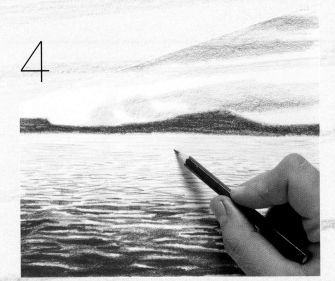

4. The areas representing the waves grow smaller and smaller as you approach the horizon, until they are so small that they can only be rendered with a very sharp pencil tip. The more gradual the transition from light to dark (from bottom to top), the more accomplished the final result will be.

5. Finally, we add some vertical bands to suggest the sunlight's reflection on the surface of the water. Then we put in the silhouette of the boat, which gives a sense of scale to the drawing, and return to the shading of the clouds, whose shape now resembles that of the waves, only without the white spots in between. The choice of a single colored pencil proves to be a good one given the tonal, rather than chromatic, quality of this subject.

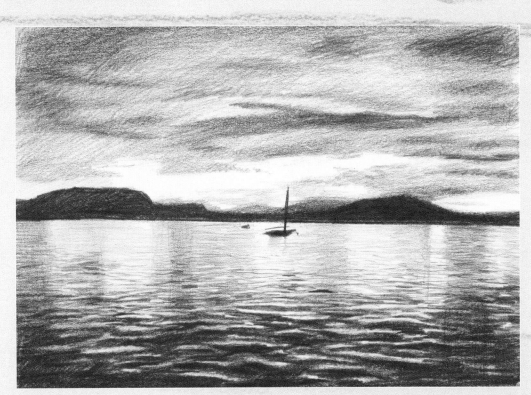

Drawing Based on a Compositional Template

Few professional landscape painters use compositional templates to draw their works. Nonetheless, it is interesting to try this method for learning purposes. The compositional template used here by David Sanmiguel will help organize the elements of a very exuberant landscape in which it is difficult to distinguish the contours of each element. For a drawing like this one, a compositional template is genuinely helpful. It provides a graphical guide and a preestablished order on which to construct the painting, piece by piece.

1. This is the template we will be using: two perpendiculars divided in the middle of the drawing, the two diagonals of the paper (which, of course, are bisected at the same point), and four shorter diagonals that cross the four rectangles created by the perpendiculars. It is now a matter of arranging the subject in relation to the lines and spaces of the template.

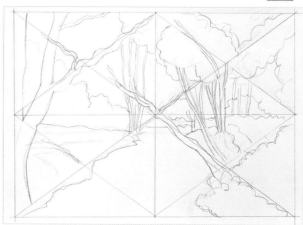

2. If you compare the subject with this first line drawing, you will see some important differences: The tree on the left is more elevated, the middle tree trunk has been shifted slightly to the right, the horizon is higher. These differences are the result of organizing, or composing, the subject within a simple linear scheme. These changes reinforce the order of the drawing; they make the work easier and give the artist confidence.

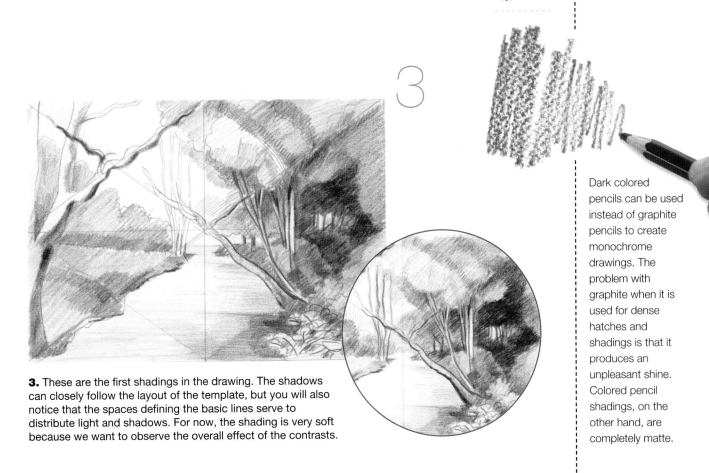

3

3. These are the first shadings in the drawing. The shadows can closely follow the layout of the template, but you will also notice that the spaces defining the basic lines serve to distribute light and shadows. For now, the shading is very soft because we want to observe the overall effect of the contrasts.

Dark colored pencils can be used instead of graphite pencils to create monochrome drawings. The problem with graphite when it is used for dense hatches and shadings is that it produces an unpleasant shine. Colored pencil shadings, on the other hand, are completely matte.

4

4. Few people would guess that this drawing was made with the help of a compositional template. If you compare it with the subject now, you will notice many differences, but the result is not artificial or lacking in spontaneity. This demonstrates that a compositional template can be something more than a routine exercise.

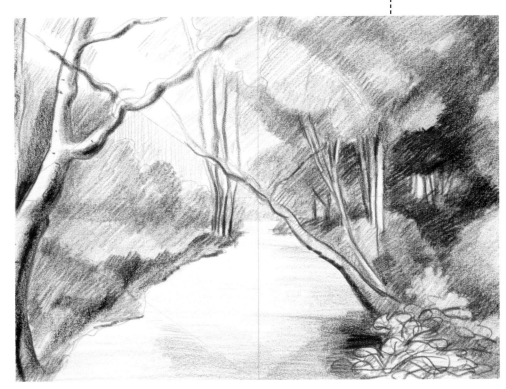

Shading Using Tonal Blocks

In landscapes, light and shade are usually never equally distributed onto objects; some objects remain completely shaded and blurred while others appear clear and sharp. As the day progresses, the sky constantly changes in brightness and luminosity, thus altering how light and shade are cast onto objects. The open sky, like the one in this next exercise in sanguine pencil by Carlant, evenly distributes the sunlight, allowing light and shade to be organized into various blocks of different tonal intensities.

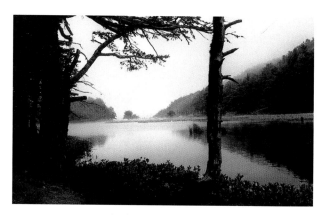

1. This preliminary sketch breaks down and organizes the essential spaces of the drawing. Each line marks the position of each element, such as the group of trees toward the left, the tree trunk in the center, the bank of the lake, etc. To ensure a harmonic composition, the horizon line descends and the central tree trunk is lightly drawn to the right so that it does not interfere with the symmetry line.

2. After the preliminary sketch is complete, the contour lines, which are lightly drawn modifications of the preliminary lines, are added to outline the various objects within the drawing, establishing the size, proportion, and composition of the various elements in the landscape.

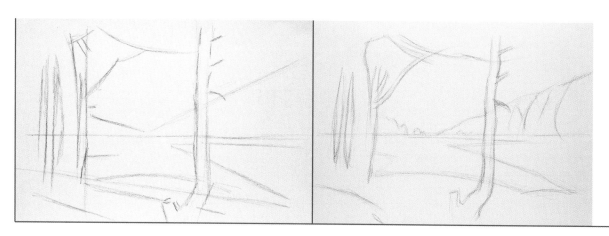

3. Once the tonal blocks have been defined by the preliminary and contour lines, begin shading with a sanguine pencil using lines. Notice how a uniform tone unites the various objects within the drawing. The group of trees to the left, for example, uses a combination of different silhouettes to define its space. When shading, the lines in the first plane of the drawing should be more intense in order to create the illusion of distance.

This preliminary pencil sketch lays out this exercise. The objects in the foreground have a darker, more intense value than those in the background. The water and sky are left white.

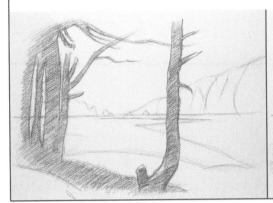 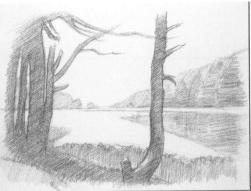

3

4. The basic technique in this exercise is to demonstrate how different objects relate to one another in terms of light and dark. The background has softer, duller lines and shading, making the objects appear far off in the distance.

4

In order to make precise value gradations with sanguine, it is better to use sanguine pencils instead of sanguine sticks. Sanguine pencils allow you to draw lines with different intensities, while sanguine sticks limit you to only using stains, which are less precise than lines.

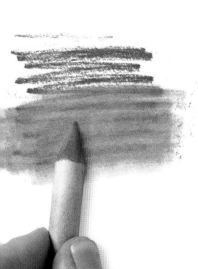

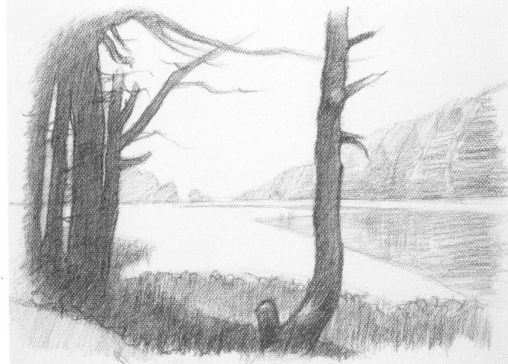

A Landscape in Simple Linear Perspective

As we have stressed before, linear perspective is a valuable graphic technique for subjects in which architecture plays a prominent role. Subjects such as this one, for example: a church seen from an angle that clearly shows the vanishing lines. The perspective is very simple, and you can see almost at first glance the position of the vanishing point in the horizon—all you have to do is extend the edges of the roof in your imagination. Indeed, imagination and graphite pencils are all one needs to render this drawing, as the artist Carlant will demonstrate.

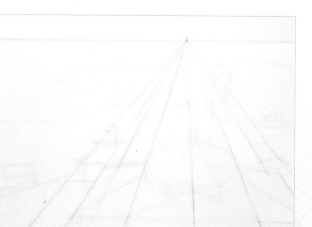

1

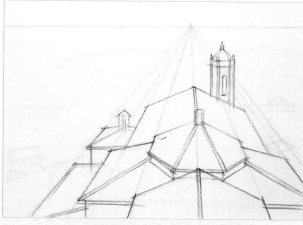

2

1. Before drawing the vanishing point and lines, you must draw the line of the horizon, then adjust the sizes of the buildings on the page. This first outline allows us to arrange the vanishing lines properly, because this is not, after all, an architectural drawing requiring very precise measurements. As you can see, the initial outline is very minimal. The vanishing lines from the rooftops are drawn based on the initial outline and a vanishing point on the horizon.

2. It is easy to situate the rooftops based on the position of the vanishing lines, if you have been careful in outlining the overall shape. After making sure that the drawing of the buildings does not show any serious disproportions, reinforce the contours in pencil, highlighting some important details such as the tower or the little belfry on the left.

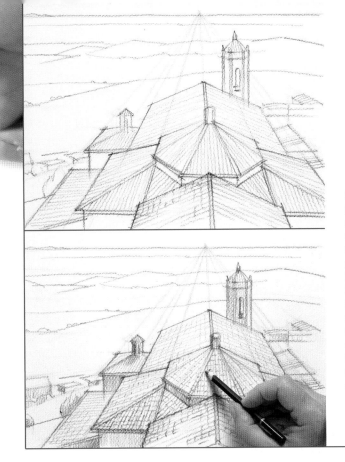

3. Then come the fields at the foot of the buildings. A few markings in line are enough to distribute these elements—the elevation of the fields and the hills that extend toward the horizon are each represented by very simple contours. Although this is an eminently line-based drawing, it might help to include some simple shadings so that the whole does not appear too stiff.

If you like, use a ruler or straight edge to make neat vanishing lines, although it is not strictly necessary for a simple perspective. For the beginner, using these instruments has a calming effect that makes the entire work easier.

3

4. The fields are elaborated upon with greater detail, including trees and vegetation and some shadings that make the drawing more pleasing and break up the monotony of the white paper. The tiles on the rooftops and the shadows of the walls also add a greater sense of naturalness to the rooftops in the foreground and help turn a simple exercise in perspective into a true landscape drawing.

4

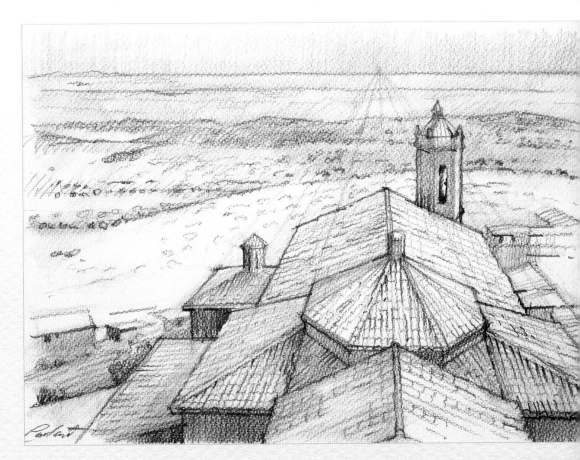

Aerial Perspective for a Landscape in Marker

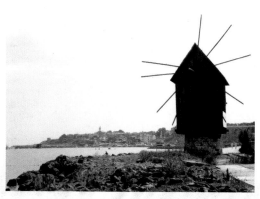

The representation of depth through the use of aerial perspective can be done with any drawing medium. Mercedes Gaspar has chosen to use markers, an unusual method but one that, in this case, produces very light results. Whenever the atmosphere plays the central role in a drawing, we leave many almost-blank spaces on the page so that the different planes of the drawing can share the same luminosity.

1. All we need for our compositional outline is a quick, loose drawing that fixes the volume of the windmill and the dimensions of the objects in the landscape. Notice the very low position of the horizon, which leaves lots of open space in the sky. These are the elements that constitute the composition of this subject.

It is a good idea to use several colored pencils in similar shades for each area of the drawing in order to link the different spaces of the drawing. The yellow tone is pale enough that it can be enhanced and elaborated upon later. The blues in the background have been enriched with strokes of pink.

1

2. Here you can already see the new colorings that enhance this overcast sky. These warm colors suggest a dense, humid atmosphere. The windmill was based on a rather light base, to which Gaspar will add more solid blue strokes. Its silhouette establishes a new spatial plane that stands out against the distant horizon.

2

3

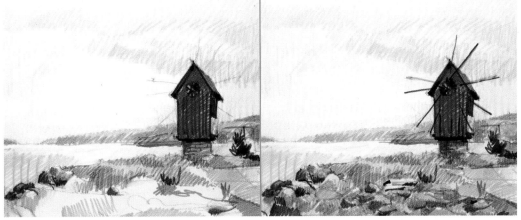

3. When drawing with markers, it is important to leave many blank spaces on the page before deciding on color and intensity. Marker forces the artist to work this way because it is impossible to correct, blend, or fade. To achieve a convincing aerial perspective, the foreground should be reinforced by adding many details and contrasts to it.

4. The rocks in the foreground are depicted by first applying several different grays, then adding light and shadow by using greens, yellows, maroons, and blues. The marked contrast between the details and colors that abound in the foreground and the simplicity of the sky and the distant planes of the drawing conveys a sensation of atmospheric space.

Alcohol-based marker dries immediately and the colors can barely be blended together. When layering different tones, they should generally belong to a single harmonic spectrum to avoid confusing effects.

4

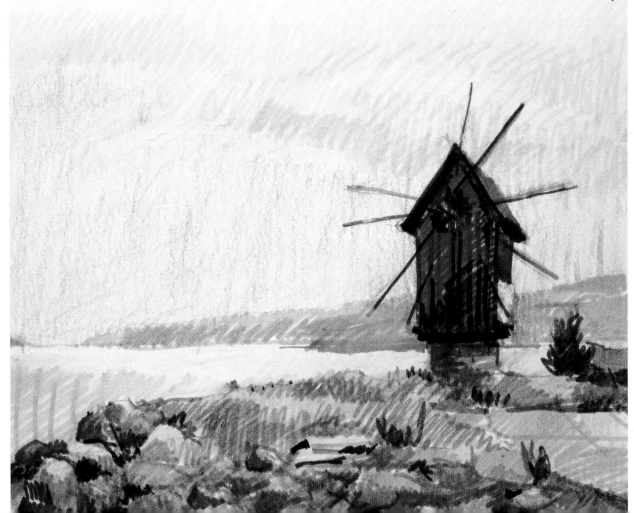

Preparations for a Drawing in Pen & Ink

The following pages show a landscape exercise in pen and ink, as drawn by Carlant. This exercise requires some preparation, not only for the framing and composition of the subject, but also for the hatchings that are needed. These preparations are important for any pen and ink drawing because there is no room for error once the work is begun.

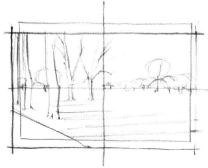

These are the basic compositional lines of the exercise. The diagonals in the lower left part are vanishing lines that unite the bases of the tree trunks in the foreground. They are drawn here to reinforce the effect of perspective. The tree can be outlined as the arches of a circle.

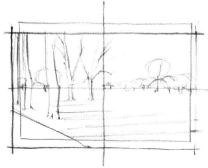

The subject is blocked just as it appears in the image (the red lines indicate the new frame). This is done, first of all, to shift the horizon line downward, away from the absolute middle of the drawing, and also to break the symmetry that divides the subject into wooded area and sky.

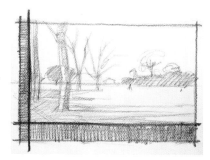

Here you can more clearly see the areas that were eliminated from the original frame—a vertical fringe on the left-hand side and a wider fringe at the bottom of the frame. The horizon is in a more interesting place, and the whole composition is much more dynamic and visually appealing.

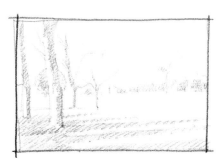

The artist takes a first approach to the arrangement of light and shadow. Here again, there is an allusion to the perspective of the composition in the diagonal tilt of the trees' shadows in the foreground. Elsewhere, the areas that are hatched and shaded in pencil will contain the greatest number of details and pen strokes.

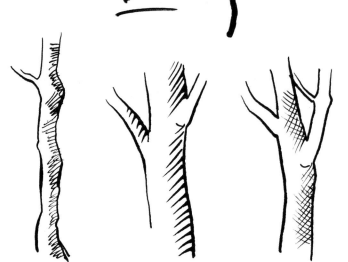

This little wooden board, lightly raised by two ribbons attached on its underside, is a very useful tool. It allows you to rest your drawing hand without touching the paper, so that you don't smudge or fade the lines in fresh ink.

This is a first approach to the hatching in this piece. Parallel hatching can be used to suggest the volume of the tree trunks. The problem with this hatching is that it only produces good results in the definition of thick volumes, and is not useful in applying fine details such as the branches of the trees.

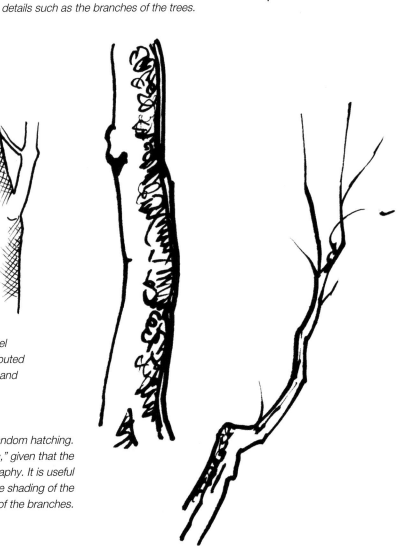

Here are some studies of a few different variations of parallel hatching. The lines can be crossed systematically, or distributed in a somewhat irregular fashion. The result is still a bit rigid and mechanical.

Finally, the artist chooses a much freer, more random hatching. This could be described as a hatching in "rubric," given that the motion of the line is reminiscent of filigrees in calligraphy. It is useful for creating the volume of shapes as well as the shading of the ground and the definition of the branches.

The preparations thus far have helped clarify the ideas behind the rendering of this landscape. The framing has been adjusted, the composition is established, and a suitable hatching style has been chosen. The next step will be a pencil drawing that shows enough detail so that the basic lines in pen and ink can be properly applied.

A Winter Landscape in Pen & Ink

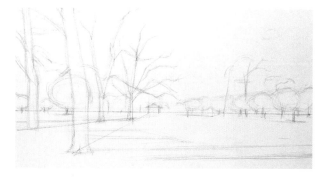

1

1. The initial drawing is much more elaborate than the preliminary drawings for any other technique. Mistakes in pen and ink cannot be corrected, and it is important to make sure that the lines you draw are correct. This drawing is based on the studies and compositional outlines shown on the preceding pages.

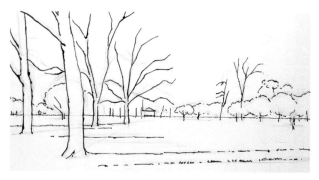

2

2. The most significant lines of the initial drawing have been redrawn in ink. These lines are slightly unconnected and discontinuous. This is done so that the hatching of shadows can fill in the parts that remain indefinite.

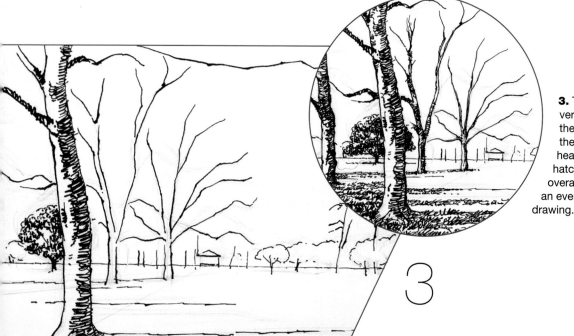

3. The hatching begins. It is very important not to make the shadows too heavy from the outset; they should grow heavier little by little, as new hatchings are added to the overall shading, to produce an even effect throughout the drawing.

3

4. This image shows that the choice of hatching style was correct. The rubric style of this hatching is very good for representing the shadows in this scene; as it shades, it also evokes the blades of grass on the ground. Furthermore, this hatching is random enough that it can accurately depict the intricate layers of the branches.

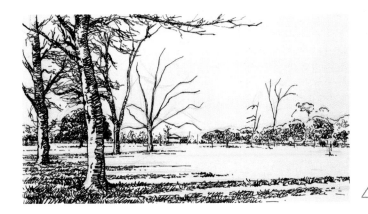

There are many different kinds of drawing and calligraphy pens. The pen used for this drawing (with an oval-shaped tip, pictured in the center, above) has a rather thick line, which lends itself to making dense shadows.

5. The entire subject is now assembled, with the artist working little by little and following closely the guidelines of the pencil drawing.

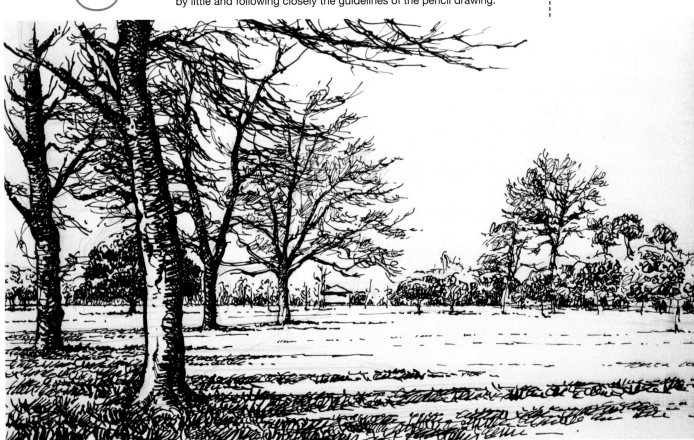

Producing Light & Atmosphere with Reeds & Ink

The possibilities of colored inks are seldom used in drawing. They are inconvenient in that they are translucent and fade over time, but by preventing exposure to an intense light source for prolonged periods, they can be preserved to an acceptable degree. Mercedes Gaspar's goal in this landscape is to produce an effect of light and atmosphere by working with rose-colored ink and a reed.

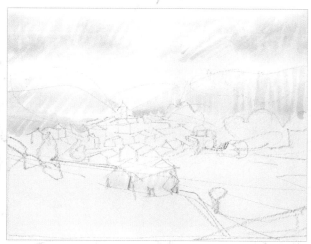

1. The center of the composition is shifted toward the left, and the basic compositional lines lead in that direction. In the lower part of the drawing, a long diagonal defines the plane where the houses in this village are clustered. The preliminary outline should allow ample space for the sky. The pencil drawing on the compositional sketch assembles the facades of the houses using repeating triangle shapes, on a larger scale in the mountainous area that surrounds the village. The trees are globes of different sizes. Every item is rendered in very simple lines.

1

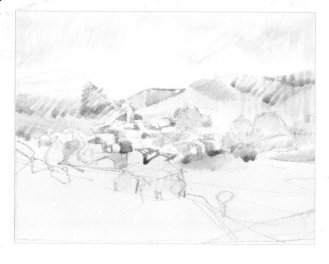

2. After slightly dissolving the ink in water, some descending diagonal strokes are added to the sky. These subtle strokes become more visible over the mountains in the background. The facades of the houses are left blank, in negative, while the rooftops are darkened.

2

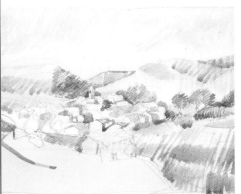

3. The strokes become thicker and more intense as they move toward the bottom of the composition. The little trees that appear here and there are represented by denser shading, made by applying the side of the reed at an angle to create finer lines. The foreground is darkened with a brush to avoid making the strokes too heavy and dense.

3

When drawing with reed, test the instrument out on a piece of scrap paper to check whether the tip is blocked and the reed is full of ink, or to discharge some of the ink on the tip to produce lighter strokes.

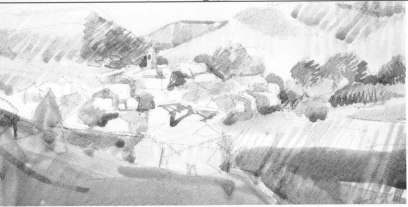

4

4. Finally, some darker details are added in the foreground and center of the drawing. This tonal contrast between the foreground and the distant planes creates the desired effect of light and atmosphere. Light appears in the blank spaces of the white paper and in the spaces between the strokes of the reed.

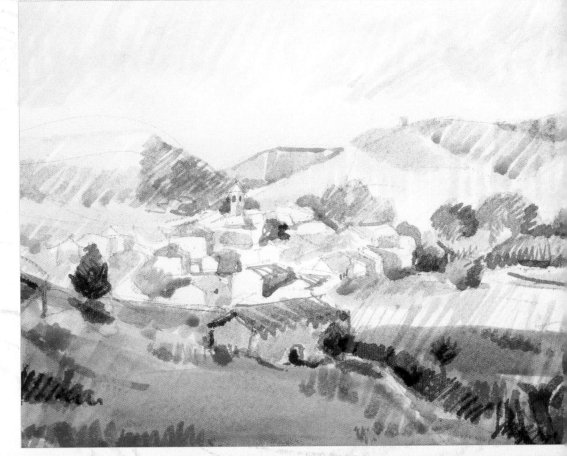

The Sky & Clouds in an Ink-Wash Landscape

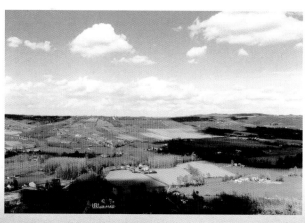

In this exercise we see how Carlant creates atmospheric perspective within a landscape dominated by a spectacular clouded sky. The point of view here is very high, so the horizon appears low in the frame. This leaves much of the space in the composition to the sky. The effect of perspective is interesting, because it affects the clouds much more than the ground. The work is in watered-down ink with highlights in white gouache on light gray paper.

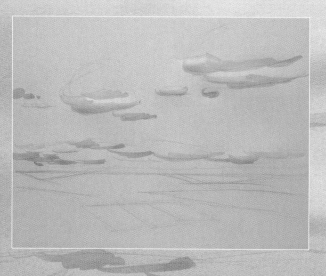

1. Carlant begins by treating the lower part of the clouds. The "belly" is always darker. The tone applied is India ink diluted in plenty of water, so that the application is very clear and liquid, barely darker than the tone of the paper itself.

2. Some ink is spread out on the field to represent the shadows of the clouds. They should be dark enough that, in contrast, they produce an effect of luminosity (as we know, light is represented by shadow, by the contrast between them). Small spots on the horizon distinguish the tones of the sky from the spaces on the ground.

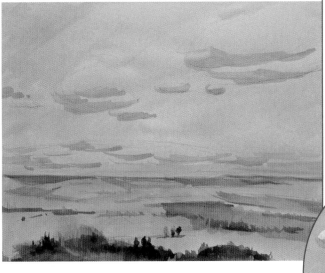

3

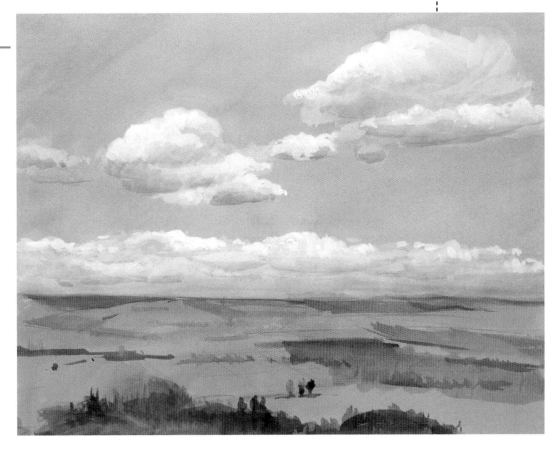

3. Notice the effect of scale produced by adding the little trees that occupy the middle ground of the drawing. Their minute size suggests the size of the broad landscape: They are a decisive factor in the proportions of the drawing. Once the shadows have been added, the light in the clouds is accentuated with white gouache; these white areas reinforce the luminosity of the entire landscape.

Ink spots on colored paper have a far less graphical effect than they do on white paper. The blacks and grays of the ink, combined with a dull foundation tone, lend beautiful subtlety to a drawing, especially when combined with white highlights.

4

4. We have seen how the panoramic amplitude of a landscape is a question of scale and luminosity, a matter of contrast. These two factors were decisive in the creation of this landscape. The final touches are in the clouds that brush the horizon and form a cottony band in which individual contours are indistinguishable. Proportion, light, and distance: three key factors finally resolved.

Aerial Perspective with a Colored Pencil Solution

At certain hours of the day, particularly at dawn, the landscape is covered in a dense mist that dissipates little by little. This vapor is the protagonist of this landscape: a great plain in which the different planes of the composition and the tree clusters succeed one another between stretches of farmland, and grow blurrier the farther away they are. This is an example of aerial perspective at its most expressive. Mercedes Gaspar develops this landscape in colored pencils watered down with a wet paintbrush.

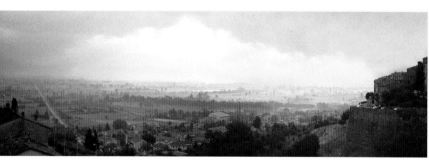

1. This simple sketch shows an important compositional decision: the drawing will not be as wide and elongated as the subject, and the buildings that bound the panorama on the left will be moved toward the center of the composition to make a tighter framing. This decision shows the degree of freedom that an artist must always exercise with regard to his subject.

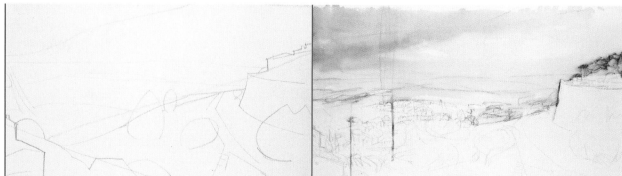

2. These lines are the basic compositional outline of the landscape, which, as you can see, is organized around a diagonal that crosses the drawing lengthwise. This diagonal in itself suggests a sense of depth, which will only be enhanced by the aerial perspective. The area of the sky and the horizon is the first to be treated. The effect here is achieved by passing a very wet paintbrush over the soft traces of the colored pencils.

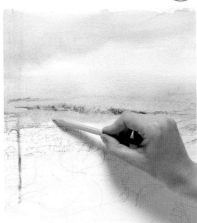

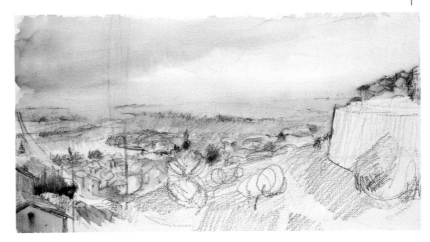

3. The horizon is lost among the clouds, but the shapes of the trees manifest themselves again after colored pencil is applied to the wet surface of the paper.

4. The drawing progresses from top to bottom, allowing the dampness of the water treatment to descend, dripping here and there toward the empty parts of the drawing. Line and spots intermingle, and the lines that represent each of the houses are also brushstrokes on a damp base. As the work advances toward the foreground, the shapes in the landscape grow more distinct, the contours ever tighter.

5. The effect of aerial perspective is achieved nicely here. There is a sensation of distance and depth, even though not all parts of the drawing have been treated exhaustively. The shapes are far more precise in the foreground, but they fade in the distance until they blend sweetly into the morning mist.

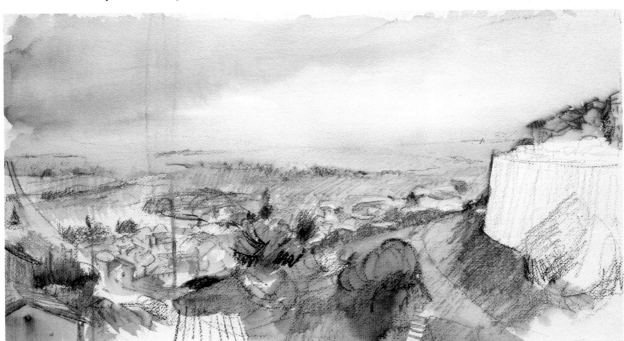

Preparations for a Composition with Masses

To understand all of the factors that operate in this exercise, study the plan developed here by Óscar Sanchís. His plan incorporates several different aspects: the chosen medium (pastels), drawing surface (colored paper), composition, and graphic resolution (strokes and blending or fading). In the following pages, we show the different decisions made before commencing the final drawing.

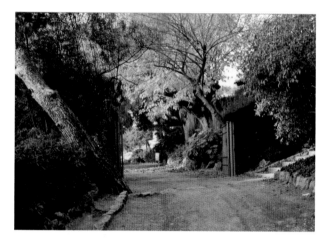

Composing a drawing of this enveloping landscape, which has no clear boundaries, requires the artist to first find the master lines that give order to the different masses. These lines are mostly diagonals, pointing toward the center of the composition. The horizon line is located below the middle of the drawing.

The darker the color of the paper, the more spectacular the highlights in light pastels will appear. But do not overuse this effect, because it can easily disrupt the balance of tonal values and turn the landscape into a spectacle of phantasmagoric evening light.

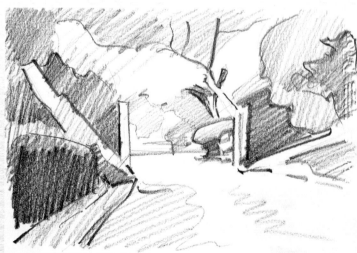

Starting from the organization of spaces that create the essential lines of the composition, we then distribute masses or blocks of different intensities. The goal is for these masses to create a convincing representation of the landscape.

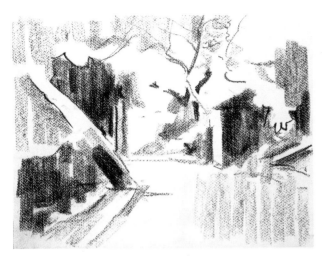

If the chosen medium is dry pastels, evaluate the effect of the distribution of masses using a similar medium, such as charcoal. Charcoal marks are much closer to those of pastels than the strokes of graphite pencils.

It is still necessary to decide upon the color of the drawing surface. With dry pastels, the results are more satisfactory when the paper is not completely white. The images below show the effects of dry pastels on lightly colored paper. The cream-colored paper is too light and contrasting for the dominant green colors, while the tone of the pink paper is too bright.

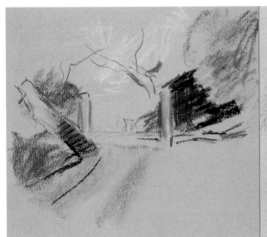
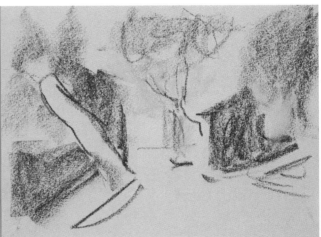

Finally, the artist chooses an olive-green paper. On it, the darker tones do not appear as solid and heavy as on the lighter colored paper, and the light tones appear vivid and harmonized within the drawing.

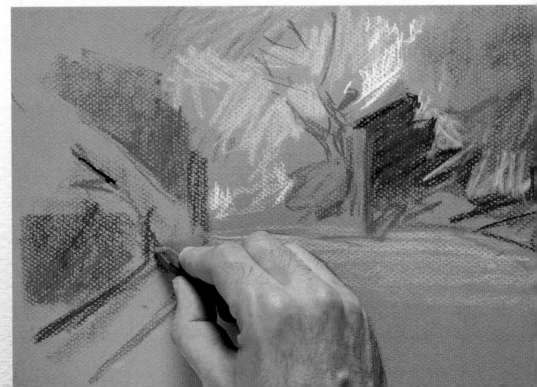

Composing with Mass:
A Landscape in Dry Pastels

Once the preliminary decisions have been made, it is time to begin the final drawing. The compositional outline is made with hard pastels in colors similar to the paper; this is the color used to establish every aspect of the drawing—outlines, shadings, and the solid areas—except the final touches, which include lighter and more vibrant colors.

1. Studying the subject attentively reveals its essential lines, which are very helpful in organizing the space of the drawing. The horizon is situated below the middle of the page. The horizon line is the starting point for marking the limits of the gate, the diagonals of the road, the tree, and the margins, as well as the outlines of the major masses of foliage.

1

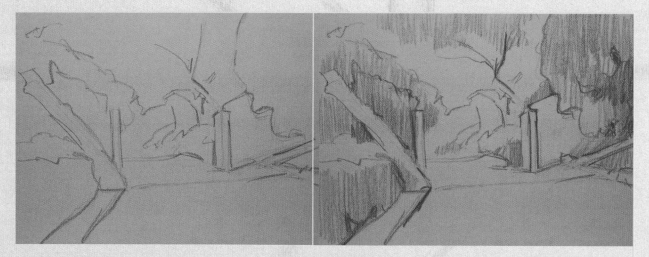

2. To enrich and complete the previous line sketch, some new compositional references have been added to break up the rigidity of the basic lines. Now the contours more closely resemble the real contours of the landscape. Once they produce a sufficiently rich image, we can begin to fill in the main masses of the trees with groups of vertical strokes that create a sense of volume.

2

3. The most solid masses are defined with spots of black pastel on the previously sketched greens. The blocks of the landscape begin to appear with clarity, and the contrast in the tonal values between them creates a clear sense of space.

3

4. Every new black or green spot is blended into the previous areas to bring the different masses together. At this stage, yellow colors are applied to one of the blocks to create a more varied chromatic effect and to lighten the heaviness of the dark blocks.

4

Dry pastels are small, rectangular bars that allow you to draw lines and create spots of color easily. The palette used here includes several greens, black, blue (to add nuance to the dark greens), yellow (to create very light greens), orange (which, when mixed with black, provides the warm colors of the path), and white.

5. Blend the different strokes by smudging them with a finger. This softens the edges and integrates the blocks with those around them. The landscape takes on a more natural, fluid appearance without losing any of the contrast and definition of its different planes.

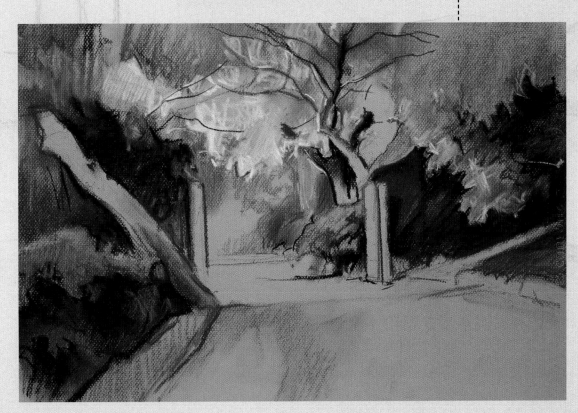

5

Técnicas Básicas del Dibujo – Dibujo de Paisaje
© 2017 Parramón Paidotribo—World Rights
Published by Parramón Paidotribo, S.L., Badalona, Spain

Brimming with creative inspiration, how-to projects, and useful information to enrich your everyday life, Quarto Knows is a favorite destination for those pursuing their interests and passions. Visit our site and dig deeper with our books into your area of interest: Quarto Creates, Quarto Cooks, Quarto Homes, Quarto Lives, Quarto Drives, Quarto Explores, Quarto Gifts, or Quarto Kids.

Published by Walter Foster Publishing, an imprint of The Quarto Group.
6 Orchard Road, Suite 100, Lake Forest, CA 92630, USA.
T (949) 380-7510 F (949) 380-7575 **www.QuartoKnows.com**

Walter Foster Publishing titles are also available at discount for retail, wholesale, promotional, and bulk purchase. For details, contact the Special Sales Manager by email at specialsales@quarto.com or by mail at The Quarto Group, Attn: Special Sales Manager, 401 Second Avenue North, Suite 310, Minneapolis, MN 55401 USA.

ISBN: 978-1-63322-417-9

Text: David Sanmiguel
Exercises: David Sanmiguel, Óscar Sanchís, Carlant, Esther Olivé de Puig, Mercedes Gaspar
Photographs: Nos & Soto
Production: Sagrafic, S.L.

Printed in Spain
10 9 8 7 6 5 4 3 2 1

MIX
Paper from responsible sources
FSC® C105485